The
Diary *of a* Young Wife
1953

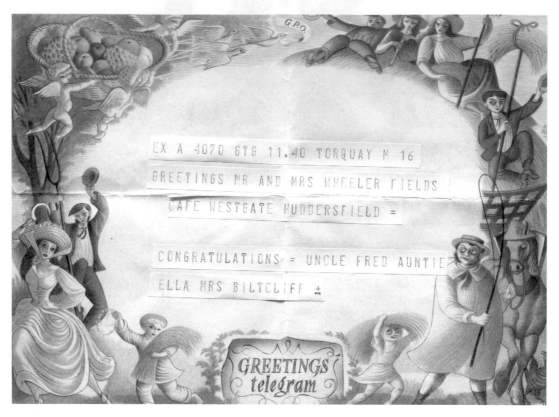

A wedding telegram, October 2nd 1952. Relieved the telegrams read out at our reception were restrained and polite—some relations can be unpredictable.

The Diary *of a* Young Wife
1953

HAZEL WHEELER

AMBERLEY

First published 2009

Amberley Publishing
Cirencester Road, Chalford,
Stroud, Gloucestershire, GL6 8PE

www.amberleybooks.com

British Library Cataloguing in Publication Data.
A catalogue record for this book is available from the British Library.

ISBN 978 1 84868 414 0

Typesetting and Origination by Amberley Publishing.
Printed in Great Britain.

Introduction

10th April 1927. A special delivery at Central Stores, Deighton, near Huddersfield. Not Wild Woodbines, Capstan, from Hobson Tobacconists, or Sugden's Flour, but a baby. Born in a bedroom above the shop. A Sunday, so the shop bell wasn't tinkling below. Not one fanfare or bulletin!

'Hurry up Hilda, I want it to arrive on my birthday', commanded Jane Taylor, proprietor with her husband John, of the village shop. And the evening was drawing on. Not always eager to be told what to do, that time, Hilda, my mother, was more than ready to deliver the goods.

The sooner the better.

Hazel Margaret was born above the shop that Sabbath evening. My brother, Philip Gordon was born on 19th October 1925. Joe Taylor, (dad) had to take on the shop after his brother Alfred died in the First World War. Whose destiny it had originally been. (10th April is a significant date, in 1985, my daughter Elizabeth gave birth to twins Adele and Charlotte, in Kent. What a blessing there was only one of me!)

Not keen on living at the shop with in-laws, especially when there were four of us, we lived in a private house on Bracken Hall Road, Sheepridge for a briefly happy couple of years. After Grandma and Grandad Taylor died, we lived at the shop until dad died suddenly of a heart attack on 18th September 1948.

Until then I could never imagine what it must be like having to go out shopping for groceries, or to live in a quiet, 'normal' house. *My* home was always bustling with customers, commercial travellers sprawled in the back room on the horsehair sofa 'telling the tale' and smoking fags. And any stray cats that wanted to live with us. Plus Prince, our adored Collie dog, who had fields at the back to roam in. Nobody went short of anything at our shop. It was a Land of Plenty. I couldn't imagine what it must feel like for some of our customers who could never manage from one week to the next. 'I'll leave a bit over till next week Joe lad', was their way of life. *They* were used to it. I suppose that made all the difference.

I was mortified when I married in 1953 and was in the same position! Whereas mother had all she needed in the shop, without having to bother ever going out shopping, apart from clothes, in 1953 I became a customer of a local

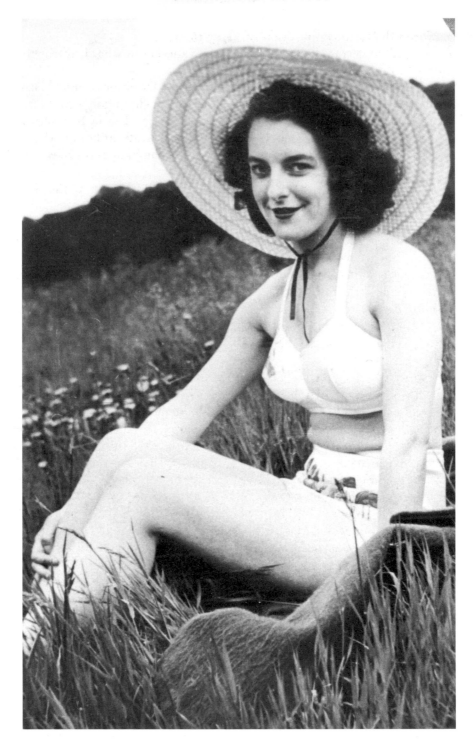

Hazel, age twenty-five. Sunshine and calm before the storms of housekeeping!

shop. Not in the fortunate position of *living* there.

Mother had no need to go out if it snowed. *I* found out what it was to be in an entirely different way of life—hard up!

Philip and I had only to walk the few yards to Deighton Council School from our shop, until we both passed the eleven-plus. Philip going (on a bus— we never had a car) to Huddersfield Boys' College, and I went to Greenhead High School for Girls, 1938-1943. After School Certificate, although Miss Hill wanted girls to stay into the sixth form, Edith McLaughlin and other friends didn't want to.

All *I* longed to be was an artist. Which I had excelled at in the School Certificate, along with English and History. Maths, I hated.

I could have been employed as an artist at once after leaving school, at Stuart Hurst Commercial Art Studios in Leeds. Dad went with me on the train taking examples of my art work. But nervous of being alone—trains then were full of servicemen, and I had no confidence alone, without Prince or dad—I went to Art School at Tech then various other places. In 1941, aged fourteen, I was rummaging in the attic of our shop when I found a 1936 Police Diary. Grandad Haigh, mother's father, had been a policeman, and died in 1937. I altered the dates to 1941, it was September, so the year remained blank until my first pencilled entry—'school'

How seemingly insignificant events alter the course of our lives! (Or could it be the force of destiny?) In 1942 I had a pocket diary from 1st January. Not one day of my life has missed being recorded since then. For many years I have enjoyed telling everything in big page-a-day diaries. A sure means of keeping sane—and one's temper—telling the diary rather than the rotter who has upset me. Why pay for memorials to those gone before, when all you need do to conjure them back is to look them up in a diary! Disputes can be resolved, addresses remembered, prices paid—treasure troves indeed.

Now, you are, presumably, in a bookshop—so buy a diary at the same time! Many say 'but nothing ever happens to me' a reason why 'not to bother' keeping a diary. How about the *Diary of a Nobody*—that book is far more entertaining than those of most celebrities!

Of course something happens to you, or you wouldn't be alive. And everybody's life is unique. I'd never have believed that my life in an ordinary Yorkshire village shop would have been published!

Even if your life doesn't become public property, keeping a diary will be a far better inheritance for your family than millions in the bank. (But not if you only write 'appointments' in it.) How I wish I knew what my ancestors *thought*, besides what they did. The emotions that singled them out to be who and what they were. *Fascinating*! When you're dead it's too late to say what you think. Do it today. Then tomorrow you may think differently, so write those contradictory remarks then. Enter what's happening in the world also—how infuriating when you can't remember the year, or what happened in your daily life—reading a diary to an elderly person who is beginning to be

forgetful works wonders also. Far more therapeutic than slouched in front of a TV set.

A diary is also an alibi, where you were, who with—who said what—my stupid solicitor marked relevant dates in my 2006 diary, then said 'but it's only your word against theirs!' *Facts* are not lies, especially if noted in your diary *when they happen*. Keep adverts, letters—if you are lucky enough to receive any in these boring technological days. Receipts for goods, even the odd Sainsbury's slip will be interesting in years to come! For comparison with prices. (See my book *Living on Tick* for some prices of goods sold in our shop, in dad's handwriting, 1922.)

How maddening my mother or dad didn't keep a diary about my life before I was old enough to record it myself. So if you have a baby, why not keep one for it and what a super present for him/her, maybe a 21st gift. That you can't buy even in Harrods. Priceless.

Can hardly believe that I am now eighty-two—especially when I read such as 1953—I'm immediately twenty-five or twenty-six again, and all over thirty are ancient. Because a diary retains your wrinkle free-youth far better than any expensive face cream—and is a darned sight more interesting!

Indeed, you have the perfect elixir of youth in your hands. Those present day twenty-somethings will be eighty-somethings in—oh, I can't add up, but hope they make sure they can turn pages back when *their* dotage is a fact! In your diary of 1950 remember, you are younger than they (my mathematical genius you see)!

Even my childhood idol Shirley Temple became eighty this year! I used to buy books and magazines about her in Woolworths in the thirties, and wonder who I'd choose to be, if I could, Shirley Temple or Princess Elizabeth—Deciding perhaps one half the week, the other one on different days.

(Oh, imagination is much more fun than reality. Write that in your diary too, what you *hope*—)

In 1953, Mavis, Josef, Philip, Audrey and I often wondered what we'd be doing in well, 2009—it didn't bear even thinking about, even admitting to being forty when it came—Granville didn't seem to bother about it as much, being of a more carefree disposition. Alas, I am the sole survivor, the one with the answers to what happened. Not sure about Mavis, but Josef died some years ago, Philip had a brain hemorrhage and died on Tuesday 16th May, 1978. Extract from my diary that day:

Wrote to Caroline and posted her sunglasses. Bank and supermarket. Just put kettle on when Auntie Annie telephoned. Philip died this morning at 4 a.m. I remember waking at four and looking at the clock. And on Sunday in early hours felt as though something was moving in my head—like my brain being turned round. Phoned Margaret. Wrote to Audrey. Went to post it down Greenhead Lane. A lady flung open her bedroom window and asked 'how's your husband?' (Granville was in the Coronary Care unit at Huddersfield Infirmary) I started to cry and said 'my

brother's died'. She ran downstairs and made me go in. Asked if I'd like a drink but I didn't. Did some washing—can't concentrate on writing. Baked sponge buns to take to mother. Called to see Elizabeth first. She burst into tears.

Said to mother it isn't Caroline, it isn't Elizabeth, not Granville—Philip—She kept repeating over and over again 'I wish I could have just spoken to him once again'. She went for Mrs Ellison to stay with her. I stayed till half-past eight, called briefly at E. and R.'s.

Paper clipped to top of the diary page a crest, The Institute of Bankers—Probus et Fudelis, and a page torn from calendar. Tuesday 16th May.

'The ablest man I ever met is the man you think you are.' I thought I'd never recover from losing my one and only brother—and when Granville died of lung cancer on 24th January 1999, the same.

The benefits to be derived from keeping a daily diary are immeasurable. The worst times pass, arguments are healed, today will never come again. Make it live forever, the only way possible. In a diary, to be treasured and passed down the generations forever and ever.

The death of Philip at fifty-two was the trigger for the onset of what is now called Alzheimer's, mother died in 'Woodleigh' on 5th June 1984. In the diary are letters from friends, photos and other memories. Syd, her second husband, died of liver cancer in St Luke's, Huddersfield, 21st January 1969.

In my diary that day I stuck a pencilled letter to 'Grandybaddy' from the then twelve-year-old Caroline:

I am writing your horoscope which is in *Schoolfriend* comic—SCORPIO. A new hairdo would make all the difference to your morale. Love, Caroline XXXXXXX

Philip, who, in 1948 had threatened to shoot Syd, telephoned to say he would come and help with the arrangements.

Auntie Annie died in St Luke's on 1st June 1985. At the end of that day's diary I wrote, 'the nurses when they came to adjust her pillows called her 'Annie darling.' I wondered if she had ever been called that in her life before. It seems so sad that all the warmth of human contact is somehow denied to many like Annie. Who erect a barricade of formality that cannot be crossed until almost the end.'

She had forbidden nurses to call her anything but 'Miss Whitworth' adhering to the formal ways she had been brought up. In that diary is the paid order for posy, pink shades, from Anne Brook, Florist, £5.50.

On Thursday 6th June. I wrote 'think Annie would have liked those better than flamboyant, garish colours. I think she would have chosen pink for her bouquet if ever she had been a bride. I wrote the card to be put with them— 'Love to Auntie Annie, with Happy Memories of old stories so often told. From Hazel, Granville and family.'

Life—a passing scene of sunshine and showers. Make sure it doesn't pass into oblivion. Other diaries include our beloved old car, Beauty. No show, old but reliable. We wouldn't change her even after Annie left us some money and we could afford to. Beauty had shared most of the happy times in our often terrible lives. Old and trusted friends, unlike 'Tried and Tested Brand New' apartments, are the ones to cherish, knowing that as long as I can turn over the pages of those, I will never lose these who meant so much to me through all the long years? We paid off the mortgage with money Annie left me.

I may not have the house of my dreams anymore, but I do have letters from Granville, written in 1952, that will always be with me—the spirit that speaks the words, are like petrol to a car. Inanimate until the vital spark is spoken, words motivate the body—words in a diary are real. To be trusted. Forever and ever. Keep one!

May I wish you happy reading with *Diary of a Young Wife 1953*

— Oh, and my friend Jeanne died of bladder cancer in 1974. She never wanted to be fifty. She achieved that wish. She was forty-nine.

<div align="right">

Hazel Wheeler,
2009.

</div>

Publishers' note: we have largely left Hazel's diary to speak for itself, keeping it all in her own words.

The Diary *of a* Young Wife
1953

❧ JANUARY ❧

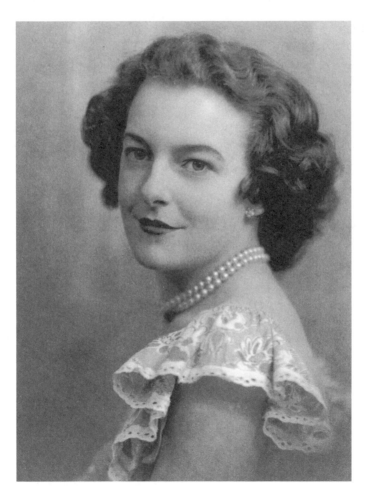

Hazel age twenty-five.

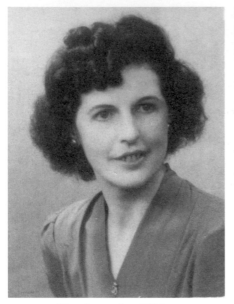

Hazel's mother, Hilda. Always an expression of 'something or someone amusing will be just around the corner'.

Auntie Ella in her youth won the 'Mrs Sunderland' musical competition in Huddersfield Town Hall. She had a choice later: a singing career or Fred Lunn, one time Huddersfield footballer. Ella chose Fred.

THURSDAY 1st January 1953
Shopping in town, home for lunch. Granville went to bed after tea, he has an aching back.

FRIDAY 2nd January 1953
Very busy washing linoleum in living-room. To Mrs Wheeler's[1] for tea. Auntie Nellie[2], who lives next door to them, came in to burn her old love letters. She read them out first, I enjoyed the evening better than any previously spent there.

SATURDAY 3rd January 1953
Town with Granville. Looking at carpets. Mother, Major[3], step-father Syd, Auntie Ella and Uncle Fred here for tea. Fred and Syd arrived after the football match. They played cards in the evening. Terribly bored with card games.

SUNDAY 4th January 1953
Joan and her fiancé Philip[4] came to tea. We had rabbit and redcurrant jelly,

1. Mrs Wheeler: Granville's mother.
2. Auntie Nellie: Granville's auntie who lived next door to his parents.
3. Major: mother's Labrador.
4. Philip and Joan (Garside): a friend of Granville's from his school days. First married Joan Hogarth and then Betty Barron after they divorced.

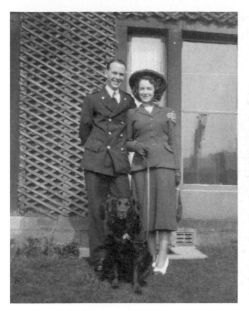

Granville, Hazel and Major outside
Granville's home.

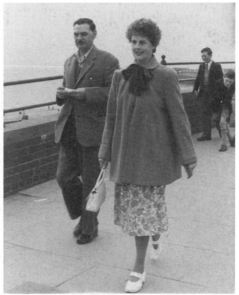

No Mediterranean cruises or trips to foreign
climes for Sydney Gregory and Hilda in
the fifties. Walking along the promenade
at Bridlington was adventurous enough for
most Huddersfield citizens then!

fruit and wedding cake. I mended Granville's pyjamas and we talked about buying carpets.

HOUSEWIFE'S HINT

Now is the time to buy a winter coat in the sales. House-linen is often reduced, but beware the remnants and tempting scarves, unless you are strong-minded enough to put them away ready to give as presents next Christmas! Some people are born bargain hunters, some are not—and the latter should stay away from sales.

Tuesday is Twelfth Night, when all decorations should be taken down.

MONDAY 5th January 1953
Washing, still by hand, and ironing. Roads slippery. We listened to the wireless.

TUESDAY 6th January 1953
Wrote letters, baked. Shopping. Walked to town rode back. Jeanne and Norman came.

WEDNESDAY 7th January 1953
To mother's for lunch. Took Major on the fields. I bought a mirror in town this

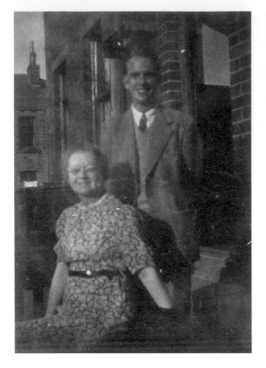

Living alone, it was reassuring to Annie to have as willing a helper as Granville when ceilings needed painting. This usually ended in a stiff neck for the helper!

Hazel, having sprained an ankle, being given a lift by pal Jeanne Wood.

morning. (£3 5s) Will be strange to be able to look in a proper big one after all this time without.

Auntie Annie came for the evening.

THURSDAY 8th January 1953
Morning, writing. Walked to town after lunch. Looking at carpets in Taylor and Hobson's with mother. She tried to console me by saying that we would have some one day. Yes, but which?

FRIDAY 9th January 1953
We overslept, so Granville stayed at home until afternoon. I cleaned the bedroom (grovelling under the bed with brush and shovel to get fluff out.) If only we had a carpet it would save so much time. Had to wash living room linoleum again, and clean the windows. Relaxed in the evening looking at magazines.

SATURDAY 10th January 1953
Granville and I to town, shopping. Looking at carpets. Light lunch in Collinson's café. Home. I was annoyed with Granville because he spent ages

trying to light a fire without wood. Rather than go down to the grocer's to buy some. No good getting any from the garden or woods, it's wet through.

SATURDAY 10th January 1953 (continued)

SATURDAY 10th January 1953 (continued)
In the evening Jeanne's mother had invited us to go to her house to watch television. Only enjoyed *Pickwick Papers*. Beginning to get that 'strung up' tenseness again, perhaps with being in a lovely carpeted house like Mrs Wood's[1], compared to ours.

SUNDAY 11th January 1953
Really, the tense feeling is because my mother-in-law is coming for tea. Baked a sponge cake which went flat in the middle. In terribly nervy frame of mind. Granville's Auntie Nellie coming too. Mrs Wheeler got on about jobs again—how one girl she knew was working full time and buying all sorts for her home. I was wild with anger. Felt better when mother, Syd and Major turned up in the evening.

Mother told Mrs W. that not many other girls could have bought as many household goods as I have done, besides paying the house deposit. She never says anything about her son not having any money.

What an ironical housewife's hint for the week beginning the 12th January!

> Begin planning summer holidays now, before all accommodation is booked up. If you think of taking a car abroad it is not too early to make enquiries of your local travel agent, since transport must be booked well in advance. It costs less than you might think to fly to the Continent with your car. [We can't afford a carpet, never mind a car.]
>
> Gardeners kept from their digging by frosts or snow should send for seed and plant catalogues and plan their spring sowing.

MONDAY 12th January 1953
11.30 a.m. to the Prudential Assurance Co. for interview for part time job. The manager asked me to type from a book, also while he dictated to me. Nerve racking. On to town, then to mother's for lunch.

MONDAY 12th January 1953 (continued)
Called at the Prudential again on my way home. Painted an old wooden buffet bright yellow after tea, and filled in a form for a freelance writing course.

TUESDAY 13th January 1953
Stuck a bright red balloon among a bunch of mimosa. It had 'Happy Birthday' printed on it. Granville is twenty-five today. I bought him a pair of socks, as

1. Mr and Mrs Wood: Jeanne's parents.

Granville's 25th Birthday. Granville used to whistle and sing *Bewitched, Bothered and Bewildered.*

well as the mirror which I acquired last week. Annie here for tea. She presented Granville with an ash tray and a fuse set.

WEDNESDAY 14ᵗʰ January 1953

Commenced working at the Prudential Assurance Company. With the manager.

Went to the Midland Bank with him in his car. Lunch is from 12.30 till 2 p.m. Typewriter was a devil of an old article—must have been a thousand years old. Stayed in all evening to recover.

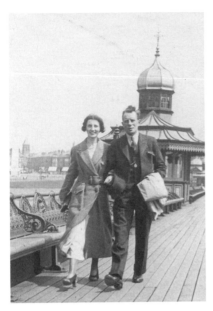

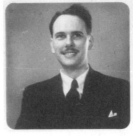
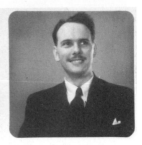

Above: two of Granville's polyfotos he gave to Hazel. Smiling always came easily to him—even in front of a camera!

Left: Auntie Ella and Uncle Fred arm in arm together on a brief holiday from pulling pints at the White Horse pub, Leeds.

THURSDAY 15th January 1953

Began work at 9 a.m. Mr Mc.C.[1] initiating me into the intricacies of the insurance business. The job wouldn't be bad—for an office—but he's so darned quiet and no fun at all. Took the post onto post office, home at 5.50 p.m. Granville to his mother's for tea, probably thinking he'd give me time to simmer down first.

FRIDAY 16th January 1953

9 a.m. work. I don't like Mr Mc.C. at all. His hands are big, fat, red and blue—more like a butcher's. Finished, thankfully, at 11.45. To mother's for lunch. We took Major over the refreshing fields—how different to being in the presence of Mr Mc.C.

FRIDAY 16th January 1953 (continued)

Back home, there was a reply from the writing school. They have read my manuscripts and recommend me for enrolment. They think I'm best on humorous stuff! fancy that, when I feel almost suicidal at times. Especially when, as in the afternoon, I was hunched over the sink in the cellar washing by hand again.

SATURDAY 17th January 1953

Met mother in town and we talked in Fields café. Granville and I to Auntie Ella's for tea. Both she and Uncle Fred, having seen our house, were urging us to sell it. Mostly because of the inconvenience of cooking and washing

1. Mr Mc.C: the manager of Prudential Insurance Company.

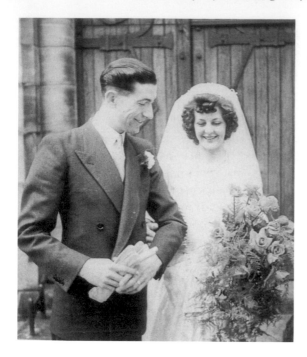

Philip Taylor, my brother, marries
Audrey Cudworth 5th July 1949.

in the cold cellar/kitchen. Watched their television in the evening. When we
were walking home we noticed a lame kitten on the road by our house, so we
brought it in.

SUNDAY 18th *January 1953*

Didn't feel too well, pains in my tummy. Probably the thought of seeing Mr
Mc.C. again, and all the unwanted, unhappy, crippled little animals roaming
the world's stage. At least I have a home to shelter from the storms in, even
though it hasn't carpets. Went to a party at Doreen and Mick[1] Gallagher's
house. Few more people there, and we played paper and pencil games and had
lots of fun.

MONDAY 19th *January 1953*

Cleaning living-room and washing again. Crying as I paused for a cup of
cocoa, feeling a brute because that poor little crippled kitten was out in the
wide world alone. It had gone out and I couldn't find it again. I was hating
the thought of going to the Prudential too. Got all ready to go—then couldn't
face it.

MONDAY 19th *January 1953 (continued)*

Wrote a letter instead, saying that I was finishing. Then went to town and on to
mother's, in case Mr Mc.C. came to see where I was. In the evening Granville

1. Mick Gallagher: married to Doreen, a friend of Mavis's, and really good fun!

ironed while I knitted. Cried again in bed. I must be run down or something. The agent from the Prudential called this evening with my wage. No work again. The advice on top of the diary for this week is as follows:

HOUSEWIFE'S HINT
Holidays are over, and store cupboards are much emptier. This is a good time to look over all bottled fruits, jams and chutneys to make sure no mould has appeared. Bottled fruit showing mould is best thrown away, but jam can be scraped clean of mould and reboiled.

Perfect housewives make a list of what is in their cupboards, pin this up and cross out each item as used. The rest of us continue to be surprised when we find we have used the last tin of soup, the last jar of tomatoes!

TUESDAY 20th January 1953
My own boss once more. Baked and washed. Mother and Major came to make sure I was alright and not depressed. At 3.15 p.m. we listened to General Eisenhower being inaugurated as President of the USA. Audrey and Philip here for the evening. Philip, very stable in his job at the bank, cannot understand why I can't be as contented.

WEDNESDAY 21st January 1953
My first lesson in journalism arrived in the post. Went to town after deciding to do full time collecting again for the PDSA. Had coffee and biscuits there, felt to be in my ideal environment, dealing with animals, out in the open air, no nasty boss leering over me. Walked home with a much lighter tread.

WEDNESDAY 21st (continued)
Met a girl I knew from Tech—she invited me to go to her home sometime. She's very nice, a nervous, highly strung type, like me!

THURSDAY 22nd January 1953
Collecting, then to mother's for lunch. Walked up the fields to Crosland Moor, more collecting, walked home. Listened to a play then listened to another with Granville after tea.

FRIDAY 23rd January 1953
Walked to town. Bought a raffia shopping bag and some meringues for mother's birthday. Lunch with her, then home to grovel fluff out from beneath bed again and dust.

SATURDAY 24th January 1953
Collecting on Greenhead Road, posh part of town. Gives me an opportunity to see what houses are like inside, also the people who live in them. Something new every minute, not the same view as in an office.

The family standby for STOMACH UPSETS

What a real friend of the family is 'Milk of Magnesia'*. Grown-ups' indigestion . . . teen-age acidity . . . the youngster's tummy upsets — 'Milk of Magnesia' dispels them all. Baby's 'windigestion' too, is soon put right. But 'Milk of Magnesia' is more than a pleasant and effective antacid—it acts gently but surely as a laxative as well. A bottle kept handy in the Medicine Cabinet ensures ready relief whenever the need arises.

'Milk of Magnesia'

Your Friend for Life

* REGD. TRADE MARK

'Prevention being better than cure' was advocated in 1953 by regular doses of a variety of medicines. For some Friday night was syrup of figs dose night, or some other fad of the time.

SUNDAY 25th January 1953

Granville to his mother's while I cooked the dinner. Wrote an article for the journalism course this afternoon. To Philip's after tea. Granville had 'wind' all evening and pains in his stomach. Not the kind of thing one expects from a comparatively new young husband.

HOUSEWIFE'S HINT

Seville oranges are now in the shops. Here is an easy recipe for marmalade. Wash 12 Seville oranges, place in pan, pour over 3 quarts water, cover and boil for 2½ hours. Turn into bowl and leave covered all night. Next day slice the oranges finely, removing pips.

Put fruit back into the water, add 10 lbs sugar, and when this is dissolved, boil for an hour or until the marmalade sets.

Home-made marmalade is much cheaper than the bought kind, but it gets eaten more quickly!

MONDAY 26th January 1953

Met mother, collecting with her. Cups of tea and biscuits in one animal lover's house. Home to wash clothes after shopping.

TUESDAY 27th January 1953

Collected at a few shops in town. Into the reading room at the public library till half past twelve. A wild, rainy day. To mother's for lunch then collecting on roads nearby. Mother soon became fed up of battling with the wind and rain

and went back home. She thinks it's a devil that I've to trail around like this.

WEDNESDAY 28th January 1953

Walked to town. Collecting at more shops then to Marsh. Took boxes into YMCA. Altogether I had £6 5s 4d. Home for lunch then collecting again. Walked there and back. Bed at 8.45 p.m. with Granville. Both of us tired out.

THURSDAY 29th January 1953

Cleaning living-room. Cleaning linoleum on bathroom floor in the afternoon. Mending socks then more washing. Wrote a children's story. If only I could be sure of selling what I write it would save slogging around in all weathers, especially as lately many aren't answering the door.

FRIDAY 30th January 1953

To local bakery for bread. Washing and usual chores. Met mother in town. I've suggested I'll give her some of the money if she helps me. But after collecting for a while in the wind and rain, hardly any response to our knocks, mother said what a waste of time it was and we came back to our house.

SATURDAY 31st January 1953

Shopping then home for lunch. To Annie's. Granville been there all afternoon, going there from work, to paint her cellar. She is going to give him a bit of something for doing it. It was 11 p.m. before we left.

HOUSEHOLD NECESSITIES

We supply every kind of cooking utensil at prices graded to suit all pockets. Our stocks of cutlery, glass and china are also worthy of your attention.

BAKING TINS, BASINS, COFFEE PERCOLATORS, DISH COVERS, DOUBLE COOKERS, ENAMELLED BOWLS, ENAMELLED WASHUPS, FISH FRYERS, FISH KETTLES, FLOUR BINS, FRYING PANS, KETTLES, MEASURES, MILK SAUCEPANS, MIXING BOWLS, PROVISION JARS, SAUCEPANS, STEAMERS, STEWPANS, TEAPOTS, ETC.

GALVANISED WARE

We offer wonderful value in good quality British Made galvanised ware for both indoor and outdoor use. Our prices are thoroughly reasonable.

AT ALL **Timothy Whites & Taylors** BRANCHES

The *Diary* of a *Young Wife*

1953

✦ *FEBRUARY* ✦

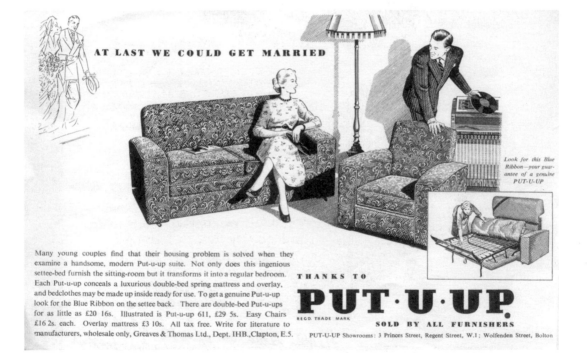

AT LAST WE COULD GET MARRIED

Look for this Blue Ribbon—your guarantee of a genuine PUT-U-UP

Many young couples find that their housing problem is solved when they examine a handsome, modern Put-u-up suite. Not only does this ingenious settee-bed furnish the sitting-room but it transforms it into a regular bedroom. Each Put-u-up conceals a luxurious double-bed spring mattress and overlay, and bedclothes may be made up inside ready for use. To get a genuine Put-u-up look for the Blue Ribbon on the settee back. There are double-bed Put-u-ups for as little as £20 16s. Illustrated is Put-u-up 611, £29 5s. Easy Chairs £16 2s. each. Overlay mattress £3 10s. All tax free. Write for literature to manufacturers, wholesale only, Greaves & Thomas Ltd., Dept. IHB.,Clapton, E.5.

THANKS TO

PUT·U·UP.

REGD. TRADE MARK

SOLD BY ALL FURNISHERS

PUT-U-UP Showrooms: 3 Princes Street, Regent Street, W.1; Wolfenden Street, Bolton

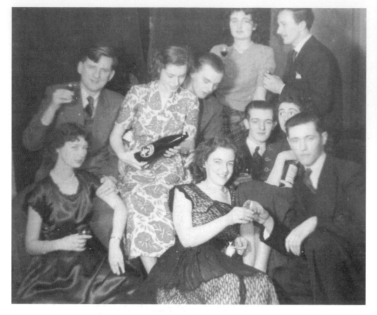

Hazel gives a party for friends from David Brown's. Josef Curtis 'toasting' the fifties, hand possessively on his bride-to-be, Mavis Wise.

Hazel enjoying out-of-office hours with friends Barbara Mitchell and Margaret Sykes.

SUNDAY 1st February 1953

I took Granville's breakfast to bed as he felt stiff from yesterday. He had a lazy day, reading the papers, having a bath. In the evening we went to the church where we were married, to the service.

HOUSEWIFE'S HINT

Salads are doubly welcome in winter, but lettuces are costly. Instead use finely shredded cabbage, sliced tomatoes, and chicory cut into rings. To make the salad go further, add raw chopped artichoke and apple, dipped in salt water to keep their whiteness. Pour over French dressing just before serving.

Many housewives are uncertain how to use garlic. Try rubbing a cut clove of garlic round the inside of the bowl before you make the salad. If the family like the flavour use it more freely.

MONDAY 2nd February 1953

Collecting with Jeanne in the evening. A man came to one door, he used to work at David Brown's when I was in an office there. He wanted me to go in—or out—with him. Glad Jeanne was with me! Heavy rain.

TUESDAY 3rd February 1953

Read in the paper about big floods all round the coasts of England and Holland. Shopping this afternoon. Went to bed early as my chest and back are aching after carrying lots of buckets of coal up the cellar steps.

Granville has 'snapped' his mother with Hazel in the garden.

WEDNESDAY 4ᵗʰ *February 1953*

To Doctor Gilmore's, felt as though I could hardly breathe. He says I've sprained the right side of my chest. He strapped it up. Wonder how I'll be able to have a bath now. To mother's for my dinner. My port of call in the storms of life! She was suitably sympathetic, felt better when I left. On to Barbara Mitchell's, whose dad died yesterday. Her mother took me to see him in his coffin. I said he looked nice. Felt a bit worse when I came away. Collected at a few houses then stayed in. Wondered how I will look in a coffin.

THURSDAY 5ᵗʰ *February 1953*

Letter from Don, a Canadian ex-boyfriend, from Canada. Idly wondered what my life would have been like now had I been a G.I. bride. Called at estate agents, fuelled with visions of sunshine and streamlined kitchens in Canada. Played hell about our house—he sold it to us. He admitted that we won't be able to get the price that we paid for it. Home to mend clothes and begin reading another book by H.G. Wells. Wrote to Don while Granville was at his mother's for tea.

FRIDAY 6ᵗʰ *February 1953*

Think I'm turning into a typical Yorkshire housewife. Cleaning the house in readiness for the weekend. I'll be hanging out of the windows next, flicking them with a wash leather. Wrote to Doreen and Mick then listened to the wireless.

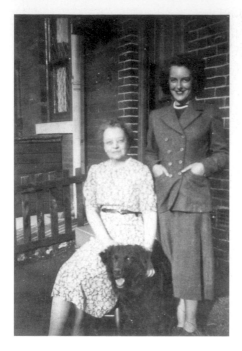

'Auntie' Annie Whitworth (ex-school teacher) who always enjoyed our visits, with Hazel and Major.

SATURDAY 7ᵗʰ February 1953

Walked to town, called at a new butcher's, Dewhurst. In-law's here this evening. Quite nice tonight. I do wish that Mrs W. was so *every* time.

SUNDAY 8ᵗʰ February 1953

Up by 8 a.m. lit the fire, took G.'s breakfast to bed. (Wouldn't have done if his mother had been aggressive last night.) To mother's after dinner. Syd is in bed with influenza, so we meandered down to Jeanne's, who invited us to stay for tea.

HOUSEWIFE'S HINT

Saturday is St Valentine's Day, and a pleasant opportunity for sentimental people.

The keen gardener plants out shallots, prunes late flowering shrubs such as ceanothus, and sprinkles hydrated lime on beds dug in the autumn for vegetables. Less hardy gardeners insist that the ground is not fit to walk on! Long sprays of forsythia will quickly come into flower if cut and brought indoors now.

MONDAY 9ᵗʰ February 1953

Writing this morning. We went to bed early to read. It was lovely with the snow beginning to fall outside, being warmly tucked up together.

TUESDAY 10ᵗʰ February 1953

Opened the curtains to reveal thick snow. I walked to the doctor's. My sprain

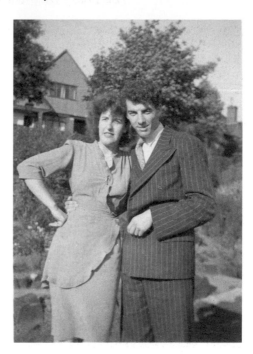

A miracle! Jeanne agrees to be snapped with Leslie Moorhouse. How much smarter people dressed in the fifties!

is better. To mother's. Syd still in bed. Poor beggar. No fires upstairs, only constant hot water bottles to keep him from freezing solid. Really, he would be better off downstairs in an armchair. But think mother prefers him out of the way. Walked home in snow. Revelling in the soft, deep whiteness of it all. Cooked tea, bed early.

WEDNESDAY 11ᵗʰ February 1953
Walked to town, taking collecting tins in. Interview at the Royal Infirmary for job as receptionist at the Princess Royal Maternity Home. In the evening a young couple came to view the house. The man sat down on the newly painted yellow buffet, and went out with a bright yellow patch on his trousers.

THURSDAY 12ᵗʰ February 1953
Cleaned cellar in case more come to view house. Mended Granville's socks. Walked to mother's in the snow, taking cake I'd baked for her. Syd still in bed, but he got up for a few tentative hours after tea.

FRIDAY 13ᵗʰ February 1953
Lucky for me! A writer at last! A postal order arrived from the local paper for 3s 6d. Cleaned living room and changed furniture round to see if it improves the appearance of the place. To Mrs Wheeler's for tea. Told her about trying to sell the house. She said that she wouldn't have advised us to have it, had we asked her. Implying, I suppose, that we ought to have done.

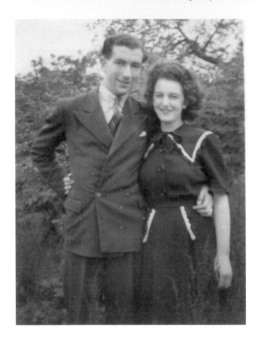

Brother and sister Philip and Hazel—
not arguing for once—in Jeanne Wood's
parents' garden.

SATURDAY 14th February 1953

A Valentine card on the table from Granville. Will save it as in future years don't think there will be any. At half past nine I met Mrs Wheeler to visit the estate agent. But he didn't arrive. Perhaps he's frightened of her too.

Baking this afternoon as Doreen and Mick are coming for tea after the football match. I did enjoy their company. We looked at photographs, talked and laughed till half past ten.

SUNDAY 15th February 1953

Cooked dinner, and Granville stayed in bed until twelve. Jeanne and Norman here for tea. Nothing interesting to say. Norman in that chin-jutting-out-saying-nothing kind of mood. We would have preferred to read.

HOUSEWIFE'S HINT

Indoor bulbs need a lot of water when they come into flower—especially hyacinths. When they die down continue to water them a little while, while the leaves are green. As soon as these shrivel, stop watering and let the bulbs get quite dry. Then lift them, shake them free of fibre and store till next autumn, when they should be put in the garden.

Whatever the weather the spring seems nearer, and the wintry sunlight suddenly grows stronger.

MONDAY 16th February 1953

Washing downstairs in the sink. Estate agent called for me in his car this afternoon to look at a house. We brought Granville out of work to come with

us. Back to town in car. Shopping then to mother's. 7.30 p.m. Granville and I met his mother in town and by bus to see the house. She's not keen on it.

TUESDAY 17ᵗʰ February 1953
Ironing. To mother's for tea. Took some grapes for Syd. He's still in bed ill. Granville came there for tea and I made my dessert speciality, pancakes, oozing with treacle and lemon juice.

WEDNESDAY 18ᵗʰ February 1953
Morning, walked to town. Called to see estate agent. Wrote an article this afternoon. To teacher Bob Brook and his wife Barbara for the evening. Talking, mostly about writing. They're a bit posh. Put coffee crystals in their coffee— never seen *them* before. Damned nuisance that I daren't invite such people to our house, with its old linoleum on the living-room floor, uncarpeted stairs and cellar kitchen. Because they are the type I enjoy talking to most of all.

THURSDAY 19ᵗʰ February 1953
Writing most of the day. Stayed in with Granville in the evening listening to the wireless. And asking him how long it will be before *we* have a smart house like Bob and Barbara have. Silence was the only reply.

FRIDAY 20ᵗʰ February 1953
After no cleaning yesterday there's a much bigger accumulation of fluff and mucky footmarks than ever, so back to cleaning today. Especially as Auntie Annie is coming this evening. She used to put an enquiring finger along the mantlepiece to test for dust when she came to our shop—where I lived for the first twenty-one years of my life—for her rations.

SATURDAY 21ˢᵗ February 1953
Shopping with Granville, and to see Mr Allinson the estate agent. Lunch— muffins and coffee—in Collinson's café. Baking in the afternoon. Didn't feel well after tea so went to bed early. Wished I hadn't when another couple came to view the house and I was part of the fixtures—in bed. They said they could only offer £1,250.

SUNDAY 22ⁿᵈ February 1953
Granville was murmuring girls' names when we were in bed. I pulled his hair and scratched him and was really mad. He said he'd only done it to tease me, but he'd been snoring in between names. Took his breakfast to bed by way of atonement for the attack. We listened to a play on the wireless after lunch, then mother, Syd and Major arrived for tea. Stoked the fire up brightly to make up for the long dreary fireless days Syd has spent in bed lately. Played cards afterwards. Joined in so there would be four of us to play.

HOUSEWIFE'S HINT
Eggs are getting more plentiful. Scrambled eggs are best cooked in a double saucepan, in which they need no watching and stay smooth and soft. Make them go further for a hungry family by serving them with fried breadcrumbs. For a colourful dish add cold cooked peas and chopped ham.

MONDAY 23rd February 1953
Washing and ironing. Talked with Mrs Kaye when hanging the clothes out. Her husband has just come home from TB hospital. The news gave me a bit of a fright, though I tried not to show it. Hope our house sells quickly! To Firth's, grocer. Enough money to buy margarine, had to ask if I could put the rest onto next week's bill. Never imagined *I'd* be shopping and not paying straightaway.

TUESDAY 24th February 1953
Up late. Granville dropped his flask and broke it. Couldn't help being annoyed, can't afford to throw money away. But as soon as he'd gone I felt sorry for him. Dashed to town, withdrew £15 from my account to pay rates and gas, and bought a new flask. Rushed home, filled flask with coffee, packed a couple of newly baked caraway buns, and took them to Granville's work. Coffee and a meringue in Sylvio's to get my breath back.

WEDNESDAY 25th February 1953
Looking at magazines so that I'll know what type of stories editors require. The grocer knocked a milk bottle over when he delivered the groceries. I felt so mortified that they hadn't been paid for that I fell and cut my finger on the broken glass. Thought it was going to bleed forever and I was going to die. Mrs Kaye wrapped it up for me, and promised that I wouldn't. Joan and Philip here this evening. Both in full time work, kitchen in their house is on the level—nothing ever seems to go wrong for them.

THURSDAY 26th February 1953
Washed the windows, studied more stories in magazines. Washed the sheets as it is just like spring today, and might dry them. Walked to town in afternoon. Bought a brassiere in Rushworth's. Tried some secondhand typewriters out. Listened to the wireless in the evening.

FRIDAY 27th February 1953
Cleaning linoleum in living-room. A boy came to mend the window. Cleaned bathroom and bedroom. In the evening to the Tudor cinema with Granville to see *The Four Poster*. Good film.

SATURDAY 28th February 1953
Shopping with Jeanne, coffee in Fields café. Afternoon, Granville and I met Auntie Annie, all to his mother's for tea.

The Diary *of a* Young Wife
1953
❧ MARCH ❧

 STATE EXPRESS 555
The Best Cigarettes in the World

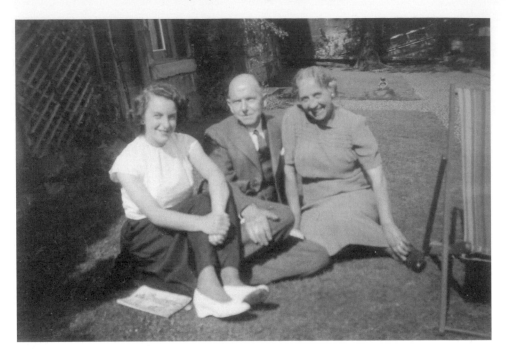

Granville's parents Mr and Mrs Wheeler. I preferred looking at magazines to having my photograph taken, especially when asked to say cheese—enough to make anyone look artificial!

SUNDAY 1st March 1953

It's foggy today. Jeanne called. I baked cakes. Auntie Ella and Uncle Fred here for tea.

HOUSEWIFE'S HINT

Before you embark on spring cleaning make sure you have all you need for it; plenty of soap and soapless detergents, ammonia, floor polish, carpet shampoo, dusters and soft cloths, Nothing is worse than to get up to your elbows in curtain-washing only to remember you have no starch.

Do not tackle too much at a time, and do not expect your family to see the need for spring-cleaning. You will almost certainly be alone in enjoying it!

MONDAY 2nd March 1953

Walked to Doctor Gilmore's, the cut in my finger keeps bursting open when I'm doing housework. He said that I should have had a stitch in it. Gave me a prescription for my cold. To mother's. Walked home. Washed and ironed. A man brought the secondhand typewriter that I bought on Saturday. It cost me £12. (What on earth would Mrs Wheeler say if she knew!)

Evening, stayed in listening to the wireless and looking at the typewriter, wondering if it will bring me fame and fortune.

FOR YOUR PHOTOGRAPH

Your photograph will last through the years, so you must look your best when you have it taken

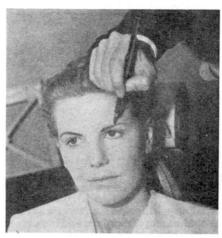

Courtesy of Max Factor

Would you believe this girl was the same as the one in the bottom photograph? If you are having your photograph taken, blemishes like uneven skin tones, redness and lines can be entirely covered by make-up. To change the appearance of too broad a jaw, a double chin or too wide a nose, highlight and shadows must be applied. A highlight should be three or four shades lighter than the foundation colour, a shadow similarly darker

The face must be clean, free from grease. Apply shadows to the jaws, if necessary. Put on foundation, smoothing with a sponge. Then put in other shadows and highlights where necessary with finger or brush. Put on another layer of foundation, then pancake

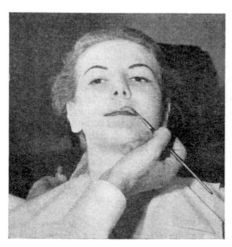

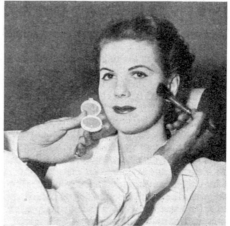

Moisten eyelids sparingly with cream, apply eyeshadow. Powder the entire make-up, buff the face with a puff. Make up the brows with a chisel-point pencil. Add a little line at the corner of the eyes; apply eyelash make-up, then lipstick. Carefully rub the areas that were shadowed and bring out just as much shadow as you wish

Brush on a little light dry rouge to make the eyes sparkle and model the cheekbones. To refresh make-up after several hours, use a lighter powder. Now you are ready for the camera!

TUESDAY 3rd March 1953
Typing article. Will never know how to change a typewriter ribbon, so only hope Granville doesn't have an accident and die. Had to go to town this afternoon to see the typewriter man. The space bar isn't right. Wrote another article after tea. Do hope I can earn the money back before long.

WEDNESDAY 4th March 1953
Typed article. Town to buy wool. Afternoon, knitting pullover for Granville and listening to the wireless. Mother, Syd and Major here for tea. Granville to bed early with a bad cold. Must hurry with the pullover.

THURSDAY 5th March 1953
My 3rd lesson arrived from the journalism course.
 When the grocer called I was so embarrassed at having not paid the bill last week that I fell over and bruised my leg. Cried for ages—even after he had gone. Suddenly wished fervently that I wasn't a 'housewife'. I know I should be spring-cleaning but I seem to have nothing to spring-clean, and I feel alone, poverty stricken and miserable. Cleaned l.room, b.room and bedroom.

FRIDAY 6th March 1953
My article came back—rejected. Granville told me 'don't worry—you get in such a temper'. I wasn't, but it annoys me that he can't see yet that I'm not made that way, to speak exactly alike all the time. Naturally, I was mildly disappointed, but not ANGRY. He was mad, so I cried again. Fire wouldn't go again either. Lunch with Philip, Audrey and another couple in Collinson's. I thought when I had a typewriter that I'd never need look for a job again. But went to a publisher's I'd read about in *Examiner* paper last night. Situations vacant columns. What a horrible place! And the man was deaf, dumb and a rogue. Life seems to be going from bad to worse, no matter how hard I try. Stayed in all evening.

SATURDAY 7th March 1953
Town with Granville. Insisted on buying Granville a black, 'Anthony Eden' type Homberg hat. To recapture some romance into my life by pretending I'm married to a diplomat or something like that. When we were back home, he said it was too small. Don't think he wanted it really. Took it back in the afternoon. They changed it. I now have only a few shillings of my own left again after drawing out of the bank yesterday. We walked to Doreen and Mick's for tea. Back on the last trolley bus.

SUNDAY 8th March 1953
Granville to his old home till dinnertime. We walked over the fields to see Major and co. later, and Philip and Audrey came here this evening.

HOUSEWIFE'S HINT

If the weather is good, gardening begins in earnest. Seeds of almost all vegetables can be sown in March, but it is a waste of time to do so if the ground is cold and wet.

Spring sunshine makes rooms look shabby. Why not distemper the walls, beginning with a small room? If you follow the directions on the tin you will find it easier than you expected, and will probably be inspired to do the whole house—but do not be tempted to tackle more than one room at a time, and get that straight before you start on the next.

MONDAY 9th March 1953

Washing. A repair man came to see the typewriter again. I made some coffee for both of us and wished I could fold him up and keep him in a drawer, if it's constantly going to go wrong like this, to bring him out when needed. Had my hair cut this afternoon—another 1s 6d paid out.

TUESDAY 10th March 1953

Audrey's birthday. I walked to Doctor Gilmore's. Finger nearly better, my cold not gone yet. Went to mother's. Couldn't get in, neighbour said she had gone to the hairdresser's. Waved to Major and blew him a kiss. Home to mend clothes and socks. And finish ironing. Listening to the wireless and knitting pullover in the evening.

WEDNESDAY 11th March 1953

To Crosland Moor to see about the job advertised in last night's paper at the Co-op. The manager wasn't in. An assistant asked me to call back again tomorrow. Walked to Standard Fireworks to make enquiries about working there. They only pay 1s 7d an hour, and it's eight in a morning till quarter past five at night. Writing and typing at home in the afternoon. Bed early, not feeling well. Mind in a turmoil of unsuitable jobs, typewriters that keep breaking down, houses that don't stay clean for more than a day at a time.

THURSDAY 12th March 1953

To the Co-op. Decided I didn't want to work there. Escape to town, library, and delicious coffee in Fields café. On to Business Equipment to complain about my typewriter. The boss brought me home in his car to collect it. The space where it stands looks terribly bereft now its gone—and all my hopes and aspirations with it. At least I can write in longhand, which I did, writing a short story then listened to a play. Walked to town after tea alone. Met mother and we went to a fashion show at a shop called Noel's.

FRIDAY 13th March 1953

Cleaned living room and bathroom. Need arms the length of an extra tall gorilla to reach to the back of the bath, underneath the claw feet. Shopping in town. Bought a bottle of egg flip—9s 6d. That means me going into the bank again tomorrow. Now I am worrying how on earth to manage till Thursday. It's hopeless this housekeeping.

But I like to have something in to offer visitors—How can anyone be expected to manage on £3 7s 6d per week?

SATURDAY 14th March 1953

SATURDAY 14th March 1953
Granville stayed in bed this morning. I went to town shopping and called at a foreign estate agents to see if he could sell our house to foreign workers. In the afternoon Barbara, Bob and their two-year-old daughter came for tea. They had to leave at 5.15pm to be back for her bed time.

 Granville and I went to his doctor's, as he had felt awful all day. Think it is his nerves—worry about money. We stayed in later and listened to a play.

SUNDAY 15th March 1953
To Auntie Ella's for tea. 'You want to get rid of that damned hole' was her theme for the day. Meaning our house and the basement kitchen. We watched their television in the evening, *As You Like It* by Shakespeare.

MONDAY 16th March 1953
To Firth's, grocer at end of road to buy a bundle of firewood. Typewriter is back. Mr Kaye came in from next door to look at taps—the hot one wouldn't turn on. I was washing, too! He made it OK. Ironing this afternoon. Took a tea service to Joan for her and Philip's wedding present. They came to our house in the evening.

 HOUSEWIFE'S HINT
 New quilts are expensive but patchwork ones are lovely. Turn out your piece bag and choose washable materials. Make a cardboard hexagon of any size you like. From it cut dozens of hexagons in paper. With these as patterns, cut out your material, allowing ½ inch turnings. Cover the hexagons, turning in edge of material and tacking through the paper. Oversew together to form a pattern of light and dark materials. When the quilt is finished, mount it on plain material, large enough to line it and to form a border. All sorts of shapes can be used, of course, for the patches.

TUESDAY 17th March 1953
Didn't get up till ten as Granville didn't go to work. He has red spots on his ankles and legs. In the afternoon we went to mother's, and for a walk with her and Major. Tea there and finished knitting his pullover. Syd went back to work today.

WEDNESDAY 18th March 1953
8.55 a.m. met mother. To a cleaners to see about a part time job. Then to a paint shop, then a café—but the hours were nine till seven in the evening there. Consoled ourselves with coffees in Fields café. Home and wrote a children's short story. Typed it in the evening.

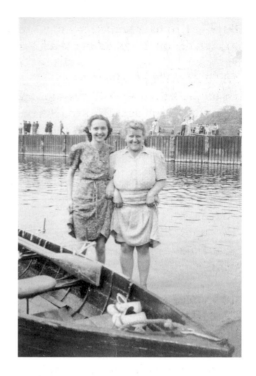

Margaret, Granville's
sister with a friend.

THURSDAY 19ᵗʰ March 1953

Polishing furniture and cleaning. 1.30 p.m. met mother in town. To Dent's, the photographers, then to the cleaners to see about a job as manageress, but wouldn't like the smell. Next to a florist's, but they had fixed someone up with the job. In despair to Sylvio's café for a restoring cup of coffee. Could have sunk through the floor when Mrs Wheeler sailed in, with friend. She came to the house in the evening to discuss part time jobs, armed with the latest copy of The *Examiner*. And Margaret. Sister-in-law.

FRIDAY 20ᵗʰ March 1953 (continued)

Only place to go to be cheered up, mother's. Granville came there for tea. Then we all went to the Plaza pictures to see the film *Folly to be Wise*.

SATURDAY 21ˢᵗ March 1953

11.45 a.m. taxi arrived to transport us to Thornton Lodge Chapel, where Philip and Joan were married. Reception at Fields café. Over five months since ours was there! Afterwards Granville and I walked to Auntie Annie's. Audrey and Philip arrived later. Annie told me off for laughing—I was very upset. A strict, studious type, she can't bear unnecessary hilarity. Yet it's the only outlet that keeps me sane when pressures of worrying about money crowd in. Walked home to save bus fares. Crying in bed until early hours.

Feel as if I'll have a nervous breakdown if life doesn't alter.

SUNDAY 22ⁿᵈ March 1953

Stayed in bed till dinner, which Granville made. Ritualistic tea-time at his mother's. Playing cards afterwards.

HOUSEWIFE'S HINT

It is not too soon to review your Spring and Summer clothes. Once you wear them you do not notice their faults, so look at them dispassionately now. Cleaning and pressing work wonders with suits, but do they still fit you? Would they be better let out or taken in? Do summer frocks want new belts or fastenings—perhaps fresh accessories? Shoes, handbags and gloves must all be studied with critical eye, and so, of course, must hats. Easter is nearly here and you must have a new one for that.

MONDAY 23ʳᵈ March 1953

Washing. Walked to town then on St John's Road to Hanson's Travel Agency to see about a job. The man said that it would be Sunday work very often, and with me being married he thought I'd wish to be with my husband. He was right, but what do I do about money—To Jeanne's in the evening with Granville. She is expecting a baby in September.

That's something else that's at the back of my mind too. If I'm going to have a baby, the sooner the better rather than having the worry of it hanging over me like a big black cloud. Not that I particularly want one, but it would be interesting to see what a child of mine would look like. And I'm twenty-five now, and twenty-six next month. Don't want to be thirty before I have any. At least then, Mrs Wheeler wouldn't be constantly pressurizing me to find work.

TUESDAY 24ᵗʰ March 1953

Up by 6 a.m. Washing, ironing and cleaned the filthy oven out. To mother's and took Major for a walk. In the evening a newsagent came to the house in reply to my letter, and offered me a part-time job at Aldmondbury.

Dealing with magazines and newspapers and other stationery and books. Quite looking forward to this one.

WEDNESDAY 25ᵗʰ March 1953

Shopping in town, mother's for lunch. Typed article this afternoon. Listened to *Cavalcade* on the wireless this evening. Queen Mary died yesterday, aged eighty-five. This was one of her favourite plays.

THURSDAY 26ᵗʰ March 1953

Re-wrote article and typed it. At 2 p.m. began working for Maurice Hall[1] at the newsagent's shop. His brother Raymond is in the shop with me, and their brother-in-law comes in later to help deal with the *Examiner*.

1. Maurice Hall: owner of the newsagent's shop I worked at briefly in March.

FRIDAY 27th March 1953

Up at 6 a.m. cleaned living room and bathroom. Walked to town after early lunch, bus to Aldmondbury. Very busy in shop till 6 p.m. Enjoyed the bustle of people coming in and out. To mother's for tea. Granville had been to the doctor's. He's OK again.

SATURDAY 28th March 1953

Up by 6.30 a.m. Dusted. Town shopping while Granville was at work. 1.30 p.m. walked to town then bus to newsagent's. Had plenty of fun in the shop. A young girl called Christine there helping. Stayed until 6.30 p.m. then Mr Hall took us to town in his car. Proudly to Mrs Wheeler's for tea. She can't complain about me now. And glad I couldn't get there any earlier though. Legitimate excuse.

SUNDAY 29th March 1953

7.20 a.m. baking. Jeanne, Norman, Mary and Jack coming to tea. Wrote a story while Granville was in the bath.

HOUSEWIFE'S HINT

Next Sunday is Easter Day. Save up your eggs for the traditional breakfast. '*HOUSEWIFE*' has given various ways of colouring them, but they look very effective served in a nest of moss sprigged with primroses.

In the south early potatoes can be planted. Roses should be pruned and suckers and weak shoots removed. This is the time to put in strawberry plants.

MONDAY 30th March 1953

Morning, writing a story. Afternoon, walked to town, bus to shop. Maurice brought me to town in his 'Vanguard' after it closed. Talking to me for twenty minutes. Went to bed early, to read *Author By Profession*.

TUESDAY 31st March 1953

Washing. Listened to Queen Mary's funeral on wireless. Made a dress into a skirt. Ironed. Quick bit of shopping before going to Aldmondbury. Only Raymond and me there all afternoon. Granville working late.

BROOMS
and
BRUSHES

LAVATORY BRUSH

SWEEPS BRUSH

Every brush or broom you buy from us has these attractive features: it is fully guaranteed, is of dependable quality, will give good service and is most reasonable in price.

BASS BROOM

BLACK BRISTLE BROOM

HAIR BROOM

COCO FIBRE BROOM

WHISK BRUSH

CARPET BRUSH

BANISTER BRUSH

CLEANING MATERIALS

We offer best values in all types of cleaning materials and of the finest quality—Polishes, Soaps, Dusters, Tea and Kitchen Cloths, etc.

AT ALL **Timothy Whites & Taylors** BRANCHES

The
Diary of a *Young Wife*
1953

✥ APRIL ✥

Every month a tonic of fresh ideas for your
house and garden — ideas that are down-to-earth
and well within the realm of reality.

Regular features on decoration, furniture,
household equipment, gardens, food and wines
make this magazine a *must* for you, the
house-proud.

You're probably already a regular reader — or are you?

House & Garden

Published monthly : **3/-** *from your newsagent
or subscription £2 for 12 issues from :*

THE CONDÉ NAST PUBLICATIONS LTD. 37 GOLDEN SQUARE LONDON W.1

Live better for less

with **House & Garden**

WEDNESDAY 1st April 1953

Up at six. To grocer's, then to town. Saw Mick and we had coffees in Fields café. He says he likes me and really enjoys my company. Thinks I'll 'get on' with writing because of my personality. How it raises the spirits to talk with someone like Mick! Began work at 3.30 p.m. Maurice brought me back to town in his car, and we talked until quarter to seven.

THURSDAY 2nd April 1953

Dad would have been fifty today had he lived. Maybe he wouldn't have liked to be so old. Up by 6.30 a.m. in a burst of energy to finish writing a story. Mrs Wheeler was here last night when Granville was working over. It was awful, she was telling me how NOT to iron Granville's shirts. He shouldn't have this, that and the other. Felt trapped with her. Walked to town, bus to work. Home in Maurice's car. Felt very tired after cooking the tea, and irritable. Mrs Wheeler always has that effect on me—it lasts for some while.

FRIDAY 3rd April 1953, GOOD FRIDAY

6.30 a.m. got up and cleaned kitchen-cellar and bathroom. Walked to town, then to mother's for lunch. Took Major for a walk. Lovely weather. Felt tired and exhausted at tea time, having to keep running up and down cellar steps. Cried with exasperation. Then to the Empire with Granville to see Errol Flynn. Didn't want to see the film and it wasn't much good.

SATURDAY 4th April 1953

A.M. baking. Granville to town shopping. P.M. did last minute shopping then to shop. Christine and I had some fun again with the customers. To town in Maurice's car. Granville had tea ready for me. We stayed in. I knitted, and we listened to the wireless.

SUNDAY 5th. April 1953, EASTER DAY

6.45 a.m. baking. 10 a.m. walked to the Baptist Chapel for a change, with Granville. Walked home after the service. Busy preparing tea for mother, Syd, Major, Mr and Mrs Wheeler and G.'s sister Margaret. Mrs W. annoyed me again before she'd been here long. Telling me not to cut so much cheese and so on. Saw mother pull a face at her behind her back. Very upset when they'd gone.

HOUSEWIFE'S HINT

Hens should soon be laying well, so buy some waterglass and see that your preserving tubs are scrubbed out ready for filling, The eggs must be new laid, but not warm from the nest box. It is safe to preserve them if they are not more than two days old. Bantam eggs can also be preserved.

Apple and pear trees should be sprayed with lime-sulpher. Indoors, watch for signs of the furniture beetle which is now active, and must be dealt with promptly.

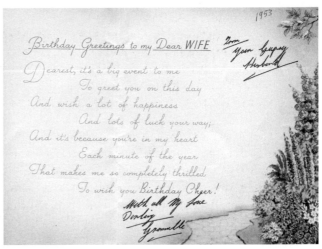

My birthday card from Granville—how much better than a telephone call. If I was in his heart every minute of the year then surely his health would suffer—he'd be too fat!

MONDAY 6ᵗʰ April 1953

Made dinner and tidied up. (But wouldn't know a furniture beetle if I saw one.) To mother's. Syd had gone to the football match. We took Major in the fields. Stayed in after coming home. Went to bed early, didn't feel well. Pains in my stomach and feeling sickly.

TUESDAY 7ᵗʰ April 1953

Granville gardening. P.M. went for a long walk. Called to see the Easter fair. Very muddy underfoot. Listened to the wireless after tea.

WEDNESDAY 8ᵗʰ April 1953

Morning, typing a story. To local shop. Washing. Afternoon, walked to town. Saw Arthur. He offered to take me to work in his car—but went the long way round. Parked his car—trying to make love to me. Managed to get to shop all in one piece. Maurice brought me to town in his car. Evening, ironing and reflecting on my narrow escape.

THURSDAY 9ᵗʰ April 1953

6.20 a.m. up to finish an article. One rejected. Met mother in town, Sylvio's café. Home for lunch. Walked back to town in record time—ten minutes. Caught the two o'clock bus to newsagent's. Cleaned the bathroom and living room on my return.

FRIDAY 10ᵗʰ April 1953

I am twenty-six years old today—oh death, where is thy sting? I suppose at this great age I'll soon be finding out the answer! Walked to mother's. Feel she ought to see me on this day, after all if it wasn't for her I wouldn't be me.

No Fresh Flowers?

Flowers are sometimes beyond the reach of our purses, but plants (which can look dull) can be so arranged that they adorn a room as cheerfully as hothouse blooms. Use trailing Tradescantia, Begonia Rex with warm pinky leaves, or satin-leafed rubber plants. Try fixing them to a lamp-standard as shown on the right

Tall sprays of Ruscus are arranged with Cape Gooseberries in an ordinary flower-pot. Cord in the same warm tangerine shade as the Cape Gooseberries is wound round the pot. Stand it in a window, and give a treat to the passers-by. Wind braid or cord around any of your pots instead of using a bowl

Above: If you cannot get firm metal pot-holders for your plants, use a hook and hold them on with cord. To prevent tipping, place a small screw under the base of the plant

A mirror is always a happy background for flowers or plants. The iron wall-brackets hold pots or trailing Philodendron or ivy sprays; there is a rubber plant on the wall-table. If you do not care for the large-leaved plants, try a copper preserving-pan filled with autumn leaves of all shades of bronze, red and green, arranged with Cape Gooseberries and yellow Immortelle

Try These Ideas

On two o'clock bus to the shop. At 6 p.m. I was about to get my coat when Raymond[1] flew into a rage because he had a choir rehearsal. But as I pointed out, I'd been told my hours were two till six, not half past.

SATURDAY 11th April 1953

Morning, on the same dreary round, looking for work. Interview at the Co-op in town for assistant in drapery department. What a dead and alive hole it looks. However, began working on the toy counter at 1 p.m. Very bored, just standing. No customers. Don't know what they wanted anybody for. Decoration?

Then told to go to haberdashery counter. Walked home to breathe freely of clean air after being stifled in there, felt an eternity until I left at 5 p.m. Granville had bought me a dictionary for my birthday yesterday, and been to the newsagent's for my money.

SUNDAY 12th April 1953

Writing another story. So fed up of nondescript jobs I suggested to Granville that if we were going to have a child why not get it over with? I reckoned that it could be all over with by January. Made him worried.

> HOUSEWIFE'S HINT
> Hardy herbaceous perennials can be sown now, also grass seed, which must be well protected from birds. This is outdoor weather for most people. Even if you are not actively gardening it is a pleasure to scrub garden furniture, renew the canvas on deck chairs and paint the greenhouse. What about fresh gravel on the paths? Have a look at the lawn mower and make sure all tools—wheelbarrows, secateurs, etc. are in working order.

MONDAY 13th April 1953

Finished writing a story. Washed clothes. Walked to work. Washed showcases and dusted toys. Hardly any customers again. Finished doing nothing at 5 p.m. Walked home. Evening, to see Mrs Mitchell and Barbara. Even though Mrs M. is newly widowed I managed to make her laugh most of the time.

TUESDAY 14th April 1953

Washing pans, baked. Walked to work. Again dusting books and washing showcases. Not many customers. How utterly boring. More interest in walking home.

WEDNESDAY 15th April 1953

Washing in cellar, then to town. Mother's for lunch. Evening, to the Plaza cinema with Granville to see *The Ringer*. Housekeeping money is finished for

1. Raymond: Maurice Hall's brother.

this week, so I paid. (Only putting this down in diary as a matter of interest in later years when we've plenty. At least, it's to be hoped we don't continue like this all our married lives.)

THURSDAY 16th April 1953

Cleaned bedroom windows, polished welsh dresser suite. It's Utility, cost us £32 last September for the Welsh Dresser, refectory table, and four dining chairs. Walked to work. A girl I know came into the Co-op. Through conversation, she told me of horrible happenings to some women when they are having babies. Walked home, mind clouded with worry. Granville had gone to his mother's for tea. I could hardly wait for his return to tell him what I'd been told about being pregnant.

THURSDAY 16th April 1953 (continued)

I was in bed, all worked up, by 9.30 p.m. Asked if he would like such things to happen to him. He makes me furious, keeps what he thinks to be a diplomatic silence in controversial matters. But I persisted. 'Would *he* like to go through having a baby?'

Eventually he had to admit that he wouldn't. Couldn't get to sleep for ages. Debating which could be worse. A lifetime dusting in the Co-op, or nasty happening which only lasted nine months.

FRIDAY 17th April 1953

When I'm worried, I find that housework is the best antidote. After lots of cleaning I walked to work. Barbara, Bob and small daughter came in and talked with me, also Mrs Mitchell. It passed the time and I kept urging them not to go, leaving me standing like a dummy trying to make work. Far prefer too much to do than too little. Mother and Syd brought Major to the house to stay while they go to Uncle Willie's tomorrow.

SATURDAY 18th April 1953

10 a.m. began 'work' at the Co-op. Went to get my coat at 12.25 and a clever devil of a junior ordered me back to the counter till bang on half past. Then the manager played pop with me for being late back after lunch. I felt tired out just standing all day. But not too tired to walk home and shake the boredom of the Co-op from my shoulders. Auntie Annie came for tea.

SUNDAY 19th April 1953

Morning, making the dinner, Granville not up till twelve. We took Major back. Later on I pushed two cushions beneath my coat to see how I'd look if I was having a baby. Horrible! I flung them to the ground and wept and stormed about how unfair it is. Both Granville and I upset. Wondering if there could possibly be a means of having a family without the bodily distortion—Tried to forget about it by writing an article.

HOUSEWIFE'S HINT

The open air, and gardening mean huge appetites. The whole family will find the Grant Loaf much more satisfying than white bread. Try it spread with dripping for 'elevenses'.

Now is the time to begin children's gardens. Seeds planted now come up quickly enough to satisfy impatient youngsters. Candytuft, Clarkia, Godetia, Virginian Stock, Nasturtium, Mignonette, Coreopsis and Flax all have good results.

MONDAY 20th April 1953

MONDAY 20th April 1953

I'd much rather be digging in the garden than going to the stupid Co-op. Cleaning the brass on counters all afternoon. Miss Thomlinson[1], a typical old maid though only twenty-five kept ordering me about all the time. At last, I said she should ask in a proper manner. I felt wild. Told the whole mouldy bunch of them I didn't intend returning. Walking on to town—stalking, rather. Saw Audrey. She walked to our house with me and stayed for tea.

Granville seemed annoyed that I had left, so I didn't speak to him all evening. Hysterical in bed. Why do jobs always turn out so lousy? Suppose because they aren't really what I want to do.

TUESDAY 21st April 1953

Back to see Doctor Gilmore again. He wrote a prescription for my nerves. Met mother at the hairdresser's. Lunch in Collinson's. Walked home. Bought myself a bottle of black beer. Mother says it's good for 'nerves'. Especially if a red hot poker is dipped into the glass!

Still working my fury against the Co-op out of my system. I wrote a letter to them. When I showed it to Granville he said I mustn't send it. We had a row. Jeanne came. Probably just as well, I would have killed him for being so insensitive, if there had been no diversion.

WEDNESDAY 22nd April 1953

Another row before breakfast over I don't know what. I don't know how it will all end. I say things impulsively, I know. To town, then on the bus to confide in Barbara. We sat out on her doorstep and talked it all over.

THURSDAY 23rd April 1953

Morning, typed a story. Wrote to Mavis[2] and washed rugs. Listened to play *A Cure for Love* on the wireless. To bread shop. On returning home found I hadn't taken the key with me. Trailed down to Jeanne's where I waited till 6.15 when I thought Granville would be back. Reading magazines after tea.

1. Miss Thomlinson: bossy upstart at the Co-op who used to order me about.
2. Mavis: my friend Mavis Wise who I first met working at Passenger Transport, Huddersfield. She married Josef Zuber, who later changed his name to Curtis.

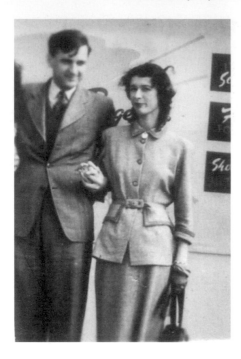

'Will I ever be a young wife?' Mavis Wise ponders, whilst time—on her wristwatch—goes marching on.

FRIDAY 24ᵗʰ April 1953
Shopping in town and looking at carpets in Furnishall. To mother's for lunch. She'd left a note—'gone to do a bit of cleaning for batchelor Eric, the local postman'.

FRIDAY 24ᵗʰ April (continued)
Walked home. A bit of a devil when my mother has a job and I haven't! Writing story till 5.15 p.m. finished writing it in the evening.

SATURDAY 25ᵗʰ April 1953
Granville to work. I forgot all my recent troubles in typing the story, visions of earning money for what I enjoy doing filling my brain. To the shop. Forgot my key again. A crowd of neighbours all trying to squeeze themselves through the front room window. Mr Kaye managed it. For all he's had TB he seems very adaptable and able to do lots of things.

In the afternoon I went to see *Syncopating Sandy* at Cambridge Road Baths. He has been playing the piano, nonstop, since Tuesday. I went on the stage and sat by him, asking him questions so I'll be able to write an article about him. A young man in the audience started asking me questions, became friendly and drove me to Annie's in his car.

Granville there, painting her ceiling and getting a stiff neck.

SUNDAY 20ᵗʰ April 1953
Wrote and typed article about Sandy. To Mrs Wheeler's for tea.

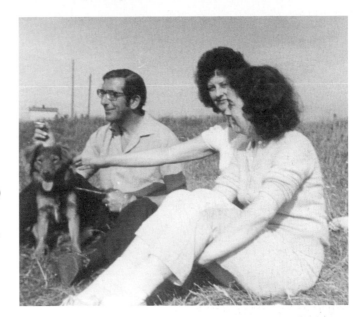

My brother Philip Taylor (cigarette in hand as usual) could afford a holiday caravan in Flamborough. Pictured here with Audrey, his wife, Bobby, their dog, and Hazel (enjoying the change!).

HOUSEWIFE'S HINT

Queen wasps are on the wing. Catch them now and save the plum crop later on! Put some jam or syrup in a jar and fill it two thirds full. Tie on a paper cover, with a half inch hole in the centre and smear a little jam or syrup round the opening. Hang the jar from a fruit tree and put one on the window ledge and see how many queen wasps you destroy.

Furs can soon be stored, either in mothproof bags or sent away to cold storage.

MONDAY 27th April 1953

Pouring with rain. Walked to town, shopping, walked back. Cleaned bathroom then wrote and typed another Sandy article. It didn't stop raining all day. We stayed in all evening. I mended socks, listened to the wireless, then read in bed.

TUESDAY 28th April 1953

Washing. Showery day. Ironing. Bed early to read.

WEDNESDAY 29th April 1953

To doctor's. My nervous spasm seems to be over for the present. Mother cleaning at Eric's again. My old high school friend Edith called this evening with husband Philip[1].

1. Edith and Philip Walker: I first met my friend Edith on the first day Greenhead High School. She married Philip Walker, who worked in the tax office.

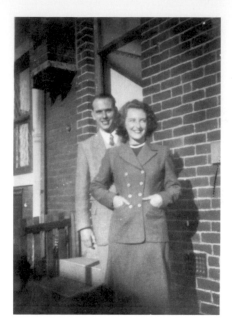

Hazel and Granville at
Auntie Annie's.

THURSDAY 30th April 1953

Feeling the need for a change I withdrew £20 from my bank. On ten o'clock
bus to Leeds. Bought a red rubber mat for the bathroom, 4s 6d, a cotton dress
to work in, 12s 11d, lunch in Matthias Robinson's. Elderly lady sat by me,
talking. Later enjoyed coffee and cakes in Fields café, Leeds. Granville had
gone to bed early. Says he has diarrhoea. How romantic.

The
Diary of a *Young Wife*
1953

∽ MAY ∾

Gracious living at its best

What a joy it is to relax; what masters of relaxation are Cunard. In these great ships you enjoy precious days that have no equal ashore. Atlantic air, convivial company, wines, cocktails, all conspire to brace and soothe you and prepare the way for meals that are truly superb. From every corner of Europe, from the U.S.A., from the East, a thousand culinary delights have been gathered. . . . There is restful quiet or sparkling gaiety. Games, cinema, carnival and dance, laughter and well being; all blend in one glorious unforgettable experience. Your Cunard days are indeed gracious. living at its best.

Cunard
—your way across the Atlantic

FRIDAY 1st May 1953

Granville didn't go to work. Looked through the *Writers and Artists' Year Book*. Then we went to town to buy carpets. Total cost for two, £41 10s. The salesman knocked me some money off for buying two or they would have been more. Bought a candlewick bedspread as well. Bank balance has dropped again. But if it will save me time, vaccing instead of constantly sweeping with a brush and shovel—To mother's for tea. Played cards with them and brought Major back with us.

SATURDAY 2nd May 1953

Granville mowing the lawn. He borrowed the mower from Mr Kaye. Jeanne called. After coffee and conversation I baked. Washed all the paintwork in front room in readiness for new carpet. Took Major for a walk then scrubbed the floorboards. And washed the doors. Granville brought fish and chips in for supper.

SUNDAY 3rd May 1953

Just like summer weather. I put some 'size' on the front room surround—the carpet is a square. Took Major home this afternoon, and sat outside till 3 p.m. Walked up the fields to Philip Garside's for tea. Very warm. We felt stifled. Especially as they had a huge coal fire burning, to get some hot water. Cooled off by walking home afterwards.

HOUSEWIFE HINT

Those who grow plump in winter because they must eat fats and sugar to keep warm, should practise slimming now. Cut out potatoes, all fried food, sweets, pastry and cakes, and give up sugar in tea and coffee. A busy housewife needs energy, so don't be tempted to forgo your meat ration (but without fat) butter, and half a pint of milk a day.

If you feel hungry at 11 a.m. or tea-time eat an apple rather than biscuits. Weigh yourself each week if you have a weighing machine, but if not measure yourself. An inch lost round the waist is far more gratifying than any number of pounds.

MONDAY 4th May 1953

Painting the wooden surround in front room with white paint. Washing, then to town with Jeanne. Drew another £30 out of my bank for carpets. Bought a lovely mirror, £5, oblong with gilt scroll round it, for the front room. Ironing in the evening, Granville gardening.

TUESDAY 5th May 1953

Gave the floor a second coat of paint. Can't wait to see finished effect! Washing, then to town for more paint, finished painting in the evening, more ironing. Granville mended a table and did some gardening.

WEDNESDAY 6th May 1953

So eager to get on with painting, up at 5.20 a.m. Spring is in the air—and in my blood! Energetically washed bathroom walls, then to mother's for lunch. Wish I was up so early every day—so much more time. Took Major through the fields. Home to write a short story. Interrupted when Jeanne and her cousin Pat called.

THURSDAY 7th May 1953

5.30 a.m. Took Granville his breakfast to bed then baking. Quite pleasant in cellar kitchen on warm days, with door open onto the back garden. Washed the stair steps and woodwork. Studied stories in magazines this afternoon.

This evening Granville and I took the drawers out of the Welsh Dresser. Intended transferring it all into the front room, to give it a cottagey effect. But lumbered it into the dividing area and had to stop—paint still tacky and wet. Instead, I washed all the glasses. Syd's nieces Christine and Sylvia called. We had cocoa and biscuits.

FRIDAY 8th May 1953

Reading magazines and writing. To town in the afternoon to buy armchair. Cost nearly £13. But do want to be able to invite people and have somewhere comfortable for them to sit down. After tea we manoeuvred the Welsh Dresser into front room and put the carpet down. Kept going back in to look at my work, and admire it.

SATURDAY 9th May 1953

Tidying living-room now it's bereft of the Welsh Dresser and washed skirting boards. Lovely walk this afternoon through the park and round Crosland Moor, with Granville, Jeanne and Norman. To their house for supper.

SUNDAY 10th May 1953

Up early baking. Had to go to bed after dinner, headache and pains in my stomach. Could be fumes from the paint.

SUNDAY 10th May 1953 (continued)

Always a snag in whatever I do. Could paint forever, I enjoy it so much, but what if it's bad for me? So proud when Doreen, Mick, Philip and Audrey were shown into the front room after tea. The first time we have used it. Granville brought some drinks in to celebrate. We all enjoyed ourselves.

HOUSEWIFE'S HINT

If you can spare sugar, make some lemon curd while eggs plentiful. Melt 1 lb of sugar (preferably loaf sugar) with ¼ lb margarine (butter, of course, is better) in a double saucepan. Beat three eggs and the yolk of a fourth egg, and stir into mixture. Add juice of two lemons and grated rinds. Stir till the curd thickens, but

it must not boil. Put into jars and seal. 1 lb of honey can be used instead of sugar. The flavour is not so sharp and the curd is sweeter, but it is very pleasant.

MONDAY 11*th* May 1953
Wrote and typed an article. Washing after lunch. To baker's for bread, called to see Jeanne. Philip Walker called to invite us to their house Thursday evening.

TUESDAY 12*th* May 1953
11.15 a.m. Dentist's. 'Not a mark on them' he said. Very gratifying—suppose that's because I don't eat sweets. Shopping, mother's for lunch. Evening, wrote another article.

WEDNESDAY 13th May 1953
Jeanne here for coffee. She went to get some bread then back for lunch. In the afternoon, while she knitted baby clothes, I washed windows, cleaned cupboards out and cleaned the bathroom. Mother called. In the evening I tidied my writing drawer while Granville painted railings.

THURSDAY 14*th* May 1953
Cleaned the bedroom and washed front room windows. Always feel a bit silly doing that when people pass by. Pleasant evening with Edith and Philip at their house. Just a few minutes walk away. They played records and we had supper.

FRIDAY 15*th* May 1953
10 a.m. went to have my hair the new 'razor' cut. To mother's for lunch, to ask her what she thought about it. Mrs Wheeler and Margaret called to inspect the front room.

SATURDAY 16*th* May 1953
Typed a story while Granville did the shopping. To Jeanne's for tea. The inevitable cards were brought out later.

SUNDAY 17*th* May 1953
Baking. Auntie Ella here at four. Mother, Syd, Major later. Uncle Fred had some excuse about having to garden. I think it is because he doesn't like Syd. The latter never says if he's enjoyed his tea, likes the carpets or anything. We had sherry trifle too.

HOUSEWIFE'S HINT
Fires will (we hope) soon be unnecessary, so arrange to have the sweep soon.

The picnic season is at hand. Are your vacuum flasks in good order? There is some excellent picnic equipment on the market now, and a supply of plastic plates, cups and containers is a good investment.

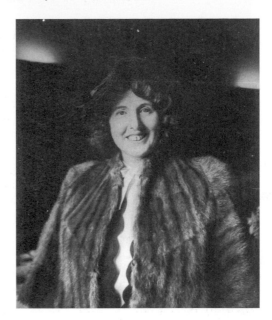

Auntie Ella. The thickness of a fur coat she wore saved her life one day when she was hit by a bus.

Main crop potatoes should be planted now. Spray vegetables and flowers for greenfly.

MONDAY 18th May 1953
Washing, ironing, scrubbing cellar steps. In the evening Granville scrubbed shelves. I tidied up, put clothes away etc.

TUESDAY 19th May 1953
10.30 a.m. Coffee with mother in Fields café. Shopping, lunch in Collinson's. I bought a tartan skirt and 'stole'. Evening, Granville painting the sides of cellar steps as though that will alter the fact that I have to go up and down them to the oven so often.

WEDNESDAY 20th May 1953
Re-wrote and typed article. Cleaning cellar in afternoon. At least housework can't be rejected. Or baking—well, perhaps sometimes. Granville gardening this evening. Then we went to bed at 8.45 p.m. to read.

THURSDAY 21st May 1953
Received £1 for a letter to *Woman's Own*. Riches! To town for a library book. Mother's for lunch. Sat on the lawn reading, Major by my side. Home, more baking. Jeanne and Norman here. They enjoy scones fresh from the oven.

FRIDAY 22nd May 1953
5.45 a.m. Washed and ironed. Lovely to be hanging the washing out when the neighbours are still in bed with the curtains drawn. Doesn't hinder me then

if they start yapping over the fence as they do so often. Cleaned bathroom, lounge (calling it that now it's slightly furnished!) and living-room. Polished chairs, washed windows. Whew! What a busy day! Oh, and cleaned shoes, and cooked tea.

SATURDAY 23rd May 1953

6.15 a.m. Up. Took breakfast to bed for Gran. Town shopping. Coffee in Fields. He kept saying we hadn't enough money for meat etc,—but we have to eat. Also he didn't look at the shops, just kept walking past them. He didn't see the point in looking at what we couldn't afford he said. I did. 'Friends' again before a dinner at home of boiled potatoes and a bit of bacon. I can't bear it when he gets that sad look on his face. At least we had an excellent tea at Mrs Wheeler's. Gran.'s cousin Sheila, Frank and their baby there too. Of course, the damned playing cards made their appearance when conversation began to flag. Better when Auntie Nellie came in to play the piano.

SUNDAY 24th May 1953

Took Gran.'s breakfast to bed. Baking while he was in the garden. Mainly talking to Mr Kaye. Walked to town after dinner, bus to Bradley Bar to see Philip and Audrey. Sat on lawn talking with them, but we weren't invited for tea. So came home for it. Evening, talking over the garden fence with Mr and Mrs Kaye. Read the paper, bed early.

> HOUSEWIFE'S HINT
>
> Whether you live in town or country, if it is fine on Whit Monday this is a day to turn your back on rampant weeds and tiresome housework and get out—to the river, to the hills, or just to the park.
>
> Carry some bicarbonate of soda. In case of insect bites damp the spot and dab on some dry powder. The irritation is eased at once.

WHIT MONDAY 25th May 1953

Tidied up then packed sandwiches. At midday Gran. and I walked to Farnley Tyas. On the way we fed a horse and lay reading in the fields. It was very hot. As we were having our picnic, dark clouds gathered. Walked as far as Aldmondbury then a bus home as the storm broke. Mother called, then we went to bed early.

TUESDAY 26th May 1953

Granville and I to mother's. Too cool to sit outside. Lunch there and took Major up the fields. Early tea then to Greenhead Park. Walked home. To bed, reading.

WEDNESDAY 27th May 1953

Granville back to work. Jeanne came up for coffee. I listened to the Queen

FRUIT BOTTLING WITH
A PRESSURE COOKER

Make sure that your bottles are sterilised and dry. Press the fruit down lightly with a wooden spoon, fill to the top

Pour on the hot syrup or water, leaving half an inch of space at the top, then place the rubber ring in position on the jar and screw the cap on firmly

Above: Put 1 pint of hot water into the cooker, and stand bottles on the inverted rack. Use the 5-lb. pressure for fruit and 10-lb. for vegetables

Right: Test to see that your bottles are properly sealed by removing the metal ring, and holding the bottle in the air by the glass top as shown in the photograph

on wireless at 2.15 p.m. To Jeanne's. Her mother was there. Afternoon tea, so la-di-da! Reading at home in the evening.

THURSDAY 28th May 1953

Bus to Honley. Interview at library. Had to answer numerous questions about books and authors. Two more women were applying for the job, but I was given it. Shopping, in high glee. Home for lunch. To mother's to tell her, and to take dear old Major up the fields. Starting as library assistant tomorrow so caught up with all the ironing while Granville was gardening.

FRIDAY 29th May 1953

Jeanne called. Mended clothes while we talked. Usual Friday task of washing linoleum on living-room floor. Left all spick and span to come home to, then on bus to Honley. Began working with Mr Amey at the branch library. There's a lot more to library work than what I imagined. We had tea together in the back room at 4.15 p.m. Closed at 7.30 p.m. Bus home. Enjoy meeting all the people coming in for books, and the atmosphere is exactly how I like it. Plus an intelligent man to talk to about writing and books, instead of illiterate louts as at so many other places I've been at.

SATURDAY 30th May 1953

10 a.m. Honley library. At counter by myself. Managed alright. The work is part-time. Mr Amey brought me back to Lockwood in his car at 12.30 p.m. I took fish and chips back for our dinner. Shopping in town with Granville afterwards. Baking, Philip and Audrey here for tea. Went for a walk, back to our house for supper.

SUNDAY 31st May 1953

Baking again. Everyone enjoys what I make so much that it's a non-stop job almost. VIPs Mr and Mrs Wheeler and Margaret and Auntie Annie here for the evening. All in front room—the lounge—talking. Feel so much more relaxed when I have a job that I look forward to.

HOUSEWIFE'S HINT
The jam and bottling seasons are near at hand. Have you got enough rubber bands, clips, covers and labels?

In the garden it should now be safe to plant out tomatoes without any protection. Town dwellers who long to grow them in window boxes are usually disappointed in the results. Unless you give them plenty of direct sunlight and rich soil they grow leggy. Put in petunias, ivy leafed geraniums and nasturtiums instead.

The
Diary of a Young Wife
1953

❧ JUNE ❧

MONDAY 1st June 1953
Washing. Brought clothes in before it thundered and lightening. Listened to wireless in the evening.

TUESDAY 2nd June 1953
We have been invited to go with Jeanne and Norman to J.'s mother's home to watch the Coronation of Queen Elizabeth II on their television set. Granville and I walked to town with them then on bus to Mr and Mrs Wood's. The Queen and Duke of Edinburgh came out of the gates of Buckingham Palace at 10.30. a.m. We saw the actual crowning in Westminster Abbey. We had tea at their house (the Woods). Home at eight, after viewing till 6 p.m. Granville was upset because he wanted to stay on longer to watch the fireworks, but Jeanne and Norman went to the pictures.

WEDNESDAY 3rd June 1953
Reading about the Coronation in the paper. To mother's after dinner. Syd at home. Tea there then to the Slaithwaite library. Worked there until 8 p.m. Mr Amey and I called at the Linthwaite branch then he brought me home in his car.

THURSDAY 4th June 1953
Catching up with neglected housework. Cleaned bathroom, living-room, and scrubbed the cellar steps. To local bakery for bread. Read *The Edwardians* (by Sackville-West).

FRIDAY 5th June 1953
To mother's for lunch. Syd there, on short time from work. So now they'll be having less money. 2 p.m. working at Slaithwaite branch. Loads of women came in asking for love stories. Plenty of laughs with them. Tea with Mr Amey. A bit embarrassing wondering what we each will unwrap for sandwiches.

FRIDAY 5th June 1953 (continued)
Finished checking up the issue of books at half-past eight. To Linthwaite branch in Mr A's car. To Mrs Wheeler's where Gran. had gone for tea.

SATURDAY 6th June 1953
Shopping with Granville. P.M. Washing and baking. Evening, stayed in reading books. I've brought a lot back from the library.

SUNDAY 7th June 1953
Tea at mother's. Walk with Major. Enjoyed reading in our lounge in the evening, happier now than for a long time.

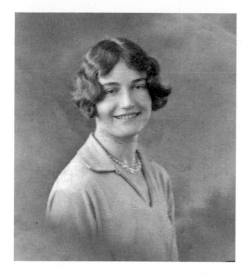

Winnie and Kenneth Halstead.

HOUSEWIFE'S HINT

Gooseberries are apt to be greeted with sighs in some households. If you have a large crop do not be tempted to bottle too many. Make them instead into chutney and ketchup, into gooseberry mint jelly and even into gooseberry wine, if you can spare the sugar (it takes 7½ lbs of sugar to 10 lbs of green gooseberries.

Have you tried gooseberry sauce (made from jam) with mackerel?

MONDAY *8th June 1953*

Darned Granville's socks and baked a cake. Washing. To Slaithwaite library in the afternoon. Mrs Denny with me. I get on splendidly with her too. Enjoy the work, and company, so much am sorry when it's time to finish.

JUNE *8th June 1953 (continued)*

At 7.30 p.m. I left library and walked home, arriving at 8.15 p.m. In such good spirits at being in a job that I love I called for a bottle of beer for Granville. Saw Leslie, who I used to be crackers on when I worked at David Brown's. He asked when I was going to buy him one—

TUESDAY *9th June 1953*

Walked to town, shopping, walked back. Baking and tidying up. Granville returned with Winnie and Kenneth[1], in their car. After tea it was such a lovely evening so Kenneth suggested a ride in the car. We went via Holmfirth right to Cheshire. Amazing how horizons enlarge when one possesses a car! Can't imagine that we'll ever have one. Home for supper.

1. Winnie and Kenneth: my cousin and her husband.

SO NICE TO
COME HOME TO

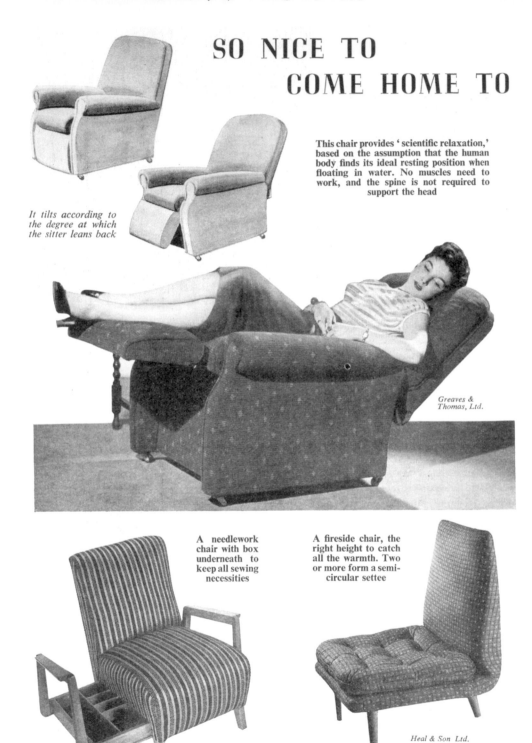

It tilts according to the degree at which the sitter leans back

This chair provides 'scientific relaxation,' based on the assumption that the human body finds its ideal resting position when floating in water. No muscles need to work, and the spine is not required to support the head

Greaves & Thomas, Ltd.

A needlework chair with box underneath to keep all sewing necessities

A fireside chair, the right height to catch all the warmth. Two or more form a semi-circular settee

Heal & Son Ltd.

It is ideal for everyone to have their own chair. If the man of the family wants to lounge with his legs over one arm, the back of the chair on the right is wide enough still to support his head

Minty of Oxford

Rocking soothes taut nerves and this is a modern version of an old favourite, made of light or dark waxed elm and beech

Furniture Industries, Ltd.

This chair comes from Switzerland and is angled for comfort

Council of Industrial Design

An ultra-modern design by Hille with steel-rod legs, latex-foam upholstery and wide wooden arms. It curves into the back and has a welcome head rest

Measure the space available for the new chair before going shopping, or you may find that it prevents a door from opening widely, or will not fit in by the fireplace or window

WEDNESDAY 10th June 1953

Washed all last night's utensils, being so late when Winnie and Kenneth left that for once I left them. Ironed, then wrote to Mavis. To the library. A young woman, Pat, helping this afternoon. Home on trolley then reading in bed after supper.

THURSDAY 11th June 1953

Happiness doesn't last long before something happens to disturb it. Twisted my neck violently when I looked up at the clock. Terrible pains. Granville to the doctor's with me. Felt better on receiving a letter from Don Davenport in Canada. Wrote back. Cleaned bathroom and living-room then at 5 p.m. until 7.30 p.m. at the library. Home on trolley with Pat.

FRIDAY 12th June 1953

Couldn't keep hairdressing appointment because of my twisted neck. To mother's for lunch after shopping. 2 p.m. working in the library with Pat. Tea with her there. Although I like Mr Amey, it's better with Pat because the room is so tiny where we eat that it feels a bit like *Brief Encounter* every time I'm munching with Mr Amey. Finished work at 7.40 p.m. To Linthwaite on bus, locked up that branch (outsized feeling of importance as I did so) then supper at Mrs Wheeler's. Granville had been there for tea.

SATURDAY 13th June 1953

Baking. Granville to work. He brought fish and chips back for our lunch. No time to cook anything because I had to be at the library for two, to open it. There on my own—completely in charge—until I closed it at four. Home for tea. We set off to go to the pictures but queues were too long. So went to Auntie Ella's and watched her television. Home after midnight, having walked from town.

SUNDAY 14th June 1953

Cooking dinner, reading paper. To mother's, then to Mrs Wheeler's for tea. RAIN—RAIN—RAIN—and FOG. It's vile June weather. Stayed there till 9.30 then home on trolley.

HOUSEWIFE'S HINT

Some people are so busy preserving their fruit that they forget to eat it while it is fresh—and what could be nicer than a gooseberry tart with plenty of syrup or sugar and 'top of the milk'?

Gardeners will be busy planting out winter greens—not forgetting sprouting broccoli. Late peas can be sown, and some carrots and swedes.

Fruit will be larger and finer if you thin out clusters of apples and pears, leaving only two or three on each.

MONDAY 15th June 1953

Rain again. Washing—hung it in the cellar to try and dry it. To mother's for an early tea before going to the library, starting at 5 p.m. till 7.45. Mrs Denny with me today. Home on trolley, bed early to read.

TUESDAY 16th June 1953

Walked to the hairdresser and back. Baking and dusting. Feel deprived when it's not the day to go to the library! Edith and Philip here this evening, talking in the lounge.

WEDNESDAY 17th June 1953

Ironing, washing, and reading *Shameful Harvest* (A.G. Street). There are so many good books in the library that if I lived to be a thousand I wouldn't get through them all. Library 5 till 8 p.m. Home on trolley, reading in bed.

THURSDAY 18th June 1953

What an even keel my life is on at the moment: cleaned living-room, mother's for afternoon tea. Library 5 till 8 p.m. Jeanne and Norman here in the evening talking.

FRIDAY 19th June 1953

Began work at the library two o'clock. Pat with me. Tea together, four till five. Lovely to be talking to somebody and be paid for it. I was in such a good mood that when Pat tentatively asked if I'd mind her going to catch a bus at 7.30 or she'd have to wait half an hour for another one, I didn't mind being left by myself to finish putting the books away and adding the charges up at all. Besides, I was going to Mrs Wheeler's, so was in no hurry to get there early!

Supper there, then home on trolley with Granville who had been to his old home for tea again.

SATURDAY 20th June 1953

Shopping in town. Could hardly wait to get to the library, starting at two o'clock. Adore being surrounded by books and talking with borrowers. In the evening Philip and Audrey came. I flew into a temper when I happened to mention all the time it took doing the housework and Philip was laying the law down about 'women should fulfill their destiny—here to have children' so on and so on.

SUNDAY 21st June 1953

Pauline, the daughter from next door, came in from ten till twelve. I was teaching her typewriting. Mrs Kaye gave me 1 lb of sugar and 1 lb of margarine by way of payment. Not that I expected any. Reading and listened to a play this afternoon, more reading after tea.

THE UP-TO-DATE
USE
OF
BRUSHES

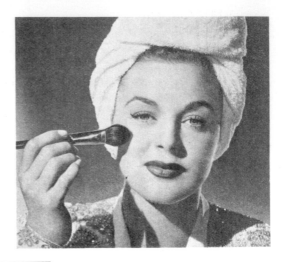

Too many girls apply a hard outline of rouge, which looks feverish rather than healthy. The use of a sable-hair brush enables the rouge to be faded off to a natural flush

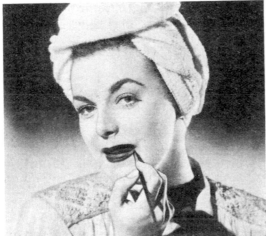

Lip-brushes can be obtained in cases for use on the dressing-table or in the handbag. It is much cleaner and more effective than using a finger, giving an even surface. Remember to finish the lipstick inside the lips

Both a brush and comb are needed for the eyebrows and can be obtained for a few pence. Brush the eyebrows the wrong way first, then smooth down in the right direction. When you comb them, it is easy to pluck out any that overlap the neat outline. Finish with a tiny touch of brilliantine. Always keep an eyebrow brush and comb on your dressing-table. They can be bought very cheaply

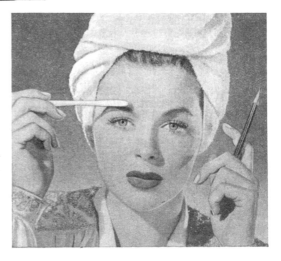

HOUSEWIFE'S HINT

Watch tomatoes for side shoots, which must be nipped off at once. (This is the season when hand towels turn yellow if you dry your hands without getting all the tomato stain off them.)

Soft roe makes an excellent meal, but many people hate handling it. Put it in a colander and plunge into boiling water. This takes away the sliminess and seems to improve the flavour. Then cut into portions, egg and breadcrumb it and fry.

MONDAY 22nd June 1953
Was in a rage at 5.45 a.m. because I couldn't get the fire to burn and I wanted hot water for washing. Also, the plug wouldn't stay in the sink. Neighbour Mrs Halstead gave me another one. Pauline came in to type. I ironed and dictated to her from a book. Working at the library with Mrs Denny.

TUESDAY 23rd June 1953
Coffee at Jeanne's. Walked to town, shopping. To mother's for tea. Granville came there after work. We talked with mother and Syd till ten o'clock. Home on trolley bus.

WEDNESDAY 24th June 1953
Cleaning the cellar. Pauline came in to type. Continued with cellar. Saw a kid opposite our house kicking a puppy. Opened window and played hell. Library at five o'clock with Mr Amey.

THURSDAY 25th June 1953
Lovely hot sunshine at last. Cleaned living-room, front room, bathroom. Mother's for tea. Library.

THURSDAY 25th June 1953 (continued)
Granville called at the library for me. We even felt able to afford a drink, into local pub for one before walking part of the way home.

FRIDAY 26th June 1953
Walked to town to do some shopping. Library with Pat this afternoon. A terrible thunderstorm when Miss Firth was assisting this evening. Home on trolley, hardly dared leave the safety of the library, lightening was so vivid.

SATURDAY 27th June 1953
Baking. 2 till 4 p.m. I held the library session by myself at Golcar Library. Walked home, arriving at 5 p.m. Read in bed after tea as I was tired.

SUNDAY 28th June 1953
Treated ourselves to a bus trip to Bridlington. Lunch at 12.30 in a café on the promenade. Had a trip out to sea on the *Boy's Own*. Walked round till

tea, which we enjoyed in another café. Strolling round again, hand in hand, then we had a sundae—delicious—in another café. Bus left for home at seven, arrived back 10.45 p.m.

HOUSEWIFE'S HINT

The strawberry season is here. If you grow your own and have too many they can be canned (your Women's Institute are probably organizing a canning session), but if bottled they lose both flavour and colour. The later, smaller fruit is best for jam making. But best of all, squander your fruit on a Strawberry Tea.

Walnuts should be ready for pickling.

MONDAY 29th June 1953

Usual round of washing, ironing and baking. Then at the library from 5 p.m. till 7.30 p.m. with Mrs Denny. She's getting on a bit, must be in her forties. Walked part way home, last bit of the way on a bus. Can never be bothered standing at a bus stop if one isn't already there. Finished ironing then read in bed—the greatest luxury in life!

TUESDAY 30th June 1953

After shopping in town, to mother's for lunch. Go there a lot because I don't want either mother or Major to feel that I've deserted them in favour of Granville. It was sunny and hot, so sat on the lawn until 3.30.

In the evening Granville and I went to Auntie Annie's. We walked with her to Ravensknowle Park, where we sat on forms surrounding the bowling green and talked.

The
Diary *of a* Young Wife
1953

❧ JULY ❧

Be gay

IN

Newman's

EVENING SANDALS

Obtainable from most leading shoe stores

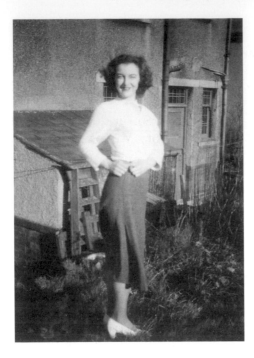

Hazel, outside mother's
house at 41 Avison Road.

WEDNESDAY 1st July 1953

Cleaned the oven then baked a cake in it. To mother's. Reading on the lawn (couldn't do that at home, one or other of the neighbours would think it an invitation to chat).

After early tea to the library. Then to Mrs Wheeler's. I helped mow their lawn.

THURSDAY 2nd July 1953

Cleaning the house. To mother's after lunch. Sat in her garden until time to begin work at the library. Finished there at 7.45 p.m.

FRIDAY 3rd July 1953

Jeanne called at our house. I walked to town with her and paid money into Midland Bank for the house mortgage. To mother's for lunch. Began at the library at two o'clock with Miss Firth. Have to choose my subjects to talk about more with her, as she is getting on and has never been married. But we have fun. We encouraged two old ladies to sing and recite for us. Tea with Miss Firth. She went out to a nearby confectioner's and brought back two delicious cream cakes for us.

On the trolley returning home a middle-aged man sat next to me and began talking. Said that I had a grand looking face and that he had taken a liking to me—!

SATURDAY 4th July 1953

9.15 p.m. Walked part way to work, then bus to Golcar Library. Very busy till mid-day. Everybody stocking up with books for the weekend. Lunch at Mrs Wheeler's—walked there—then walked to Slaithwaite Library. There until four.

In the evening Gran. and I went to Auntie Ella's. Sat in the garden, had a sherry. Very civilized! Went in to watch television. Walked home after midnight.

SUNDAY 5th July 1953

Baked a cake. Gran.'s sister Margaret came for lunch. Then we packed sandwiches and went by bus to Parkhead on the moors above Holmfirth. Sat in a field, talked to a farmer, had our picnic. Walked to Holmfirth. Home on the bus.

HOUSEWIFE'S HINT

Pick and dry your lavender this week, spreading it out on a sheet of newspaper. A lavender bag under each pillow is appreciated by everyone, but they should be washed and the lavender renewed each year—pleasant job for the children!

This is the time of year to cut down housework to a minimum and make every excuse for getting out of doors. Supper in the garden on fine evenings is lovely but only if it is a cold meal with salad. Hot dishes mean too much carrying for the housewife!

MONDAY 6th July 1953

Washing. Ironing in the afternoon until time to get ready to go to the library, commencing at 5 p.m. The man who sat by me on the bus came in. Making overtures—said I was 'beautiful' and other compliments. So I told him if he had come in just to talk silly he had better go. Didn't fancy being raped among the fact and fiction. Home on 7.30 p.m. bus and finished the ironing.

TUESDAY 7th July 1953

Met Jeanne in town. To her mother's (the latter away on holiday.) We picked gooseberries, blackcurrants etc. from her dad's allotment. Home, cooked tea and made a pie with some of the fruit. We walked to mother's, Gran. and I. She was at Eric's, cleaning for him. We took Major up the fields then called for mother. All had supper at Eric's.

WEDNESDAY 8th July 1953

Looked at ovens in gas showroom. Bought small blue Formica table in Heywood's. £4 15s. Will save time after baking instead of scrubbing the old wooden one in the cellar. To mother's for lunch and baked two pies for her with some of the fruit gathered from the allotment. Wrote an article. To the library. Dr Kirk's son came in to change his books at 7.25 and didn't leave

FIGURE TRIMMERS

To limber up each day is important. Jump up and down on your toes as if skipping. Swing each leg backwards and forwards, several times, then the arms

Waist-liner. Stand upright, legs apart, left hand on hip and right hand behind your head. Move trunk slowly to the left, keeping head and legs straight. Return to upright position, change position of arms, and bend other side. Repeat five times each side

Hip-reducer. Sit on the floor cross-legged, hands at sides. Rock slowly from side to side so that pressure is felt on hips. Uncross legs, take weight on your hands, lift hips from ground, lower them with a bump ten times or more daily

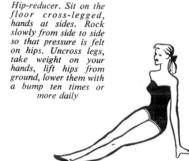

Above: Tone up those tummy muscles. Sit on the floor, knees bent, arms outstretched. Incline slowly backwards, straightening and raising legs. The arms, which will help the balance, should be drawn towards the chest. Keep movements smooth. Ten times

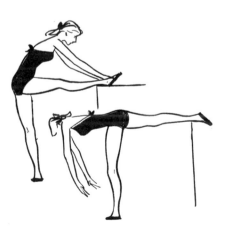

At right: Lovely legs: Stand upright, legs straight. Support right foot behind, turn and touch it, legs stiff. Bring body upright, then slowly bend to touch foot on floor. Six times each foot

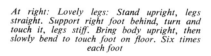

until 7.45 p.m. But who minds people staying late when they are such good conversationalists? Home on eight o'clock trolley.

THURSDAY 9th July 1953

Cleaned bathroom and living room. Then baked more fruit pies before the gooseberries and other things 'go off'.

To the library, calling at Mrs Wheeler's for supper.

FRIDAY 10th July 1953

Sorted writing manuscripts out. In a bit of a jumble. Jeanne called to see me. 2 p.m. at the library with Mr Amey. Home on 7.45 bus.

SATURDAY 11th July 1953

Walked to town. Coffee in Collinson's with Betty Key[1] and two male musician friends of hers. Walked home. Library for two o'clock. Granville went to Mr Wood's to pick more fruit. Wish we had some fruit bushes to save us money.

Evening, with Jeanne and Norman and Gran. to the Curzon to see *The Cruel Sea*.

SUNDAY 12th July 1953

Took Gran.'s breakfast to bed. Baking. Pauline asked if she could come in to use my typewriter. Pouring with rain all day. The Wheelers here for tea. Played the piano in the evening.

HOUSEWIFE'S HINT

For those who grow much soft fruit this is a busy season. Raspberries need constant picking. They make wonderful jam and jelly and they keep both flavour and colour if bottled. If you have a great deal of surplus fruit and vegetables it is worth your while to buy a canning outfit. Ask your local hardware shop for details or, better still, see a demonstration.

But once more in your enthusiasm for preserving fruit, don't forget that fresh raspberries are nicer than almost any other dish. It is as well to use syrup for cooking at this season—your sugar will be sprinkled on fresh fruit.

MONDAY 13th July 1953

Washed a few clothes. Pouring with rain. To mother's, then to the library with Mrs Denny.

TUESDAY 14th July 1953

Major arrived here by himself. Had to go to the hairdresser for hair cutting. In the afternoon washing again. Tea with Major and Gran. Mother came to see if Major was here. And Edith and Philip called.

1. Betty Key: a lifelong friend, Betty was first met by my brother Philip during the war.

WEDNESDAY 15th July 1953

It must be awful for Major, not knowing why I have stopped living with him. So after cleaning bathroom, bedroom and the oven walked to see him again. Tea there, walked to Linthwaite then on bus to Slaithwaite library. Finished at eight, home on bus and read in bed.

THURSDAY 16th July 1953

6.30 a.m. Took breakfast up to bed for Granville. Made some lemon cheese and cleaned living-room. Mrs Kaye gave me my dinner—she passed two plates over the garden fence!

To mother's then the library. A young married woman stayed talking with me until eight o'clock. Home on trolley.

FRIDAY 17th July 1953

Shopping in town then Fields café with a girl I started talking to. Don't know her name. Looking round a modern kitchen in Mollet's shop. Which made me even more fed up of having to chase up and down our cellar steps every time there's a meal to be made. Started to cry—can't see how it can be altered. To mother's for lunch—and sympathy. She agreed that it's ridiculous too.

Wet through waiting for trolley bus to the library. Miss Firth with me today. Home on 7.45 bus. Straight to bed. Granville stayed downstairs because he said he was trying to think a way out of this cellar kitchen business.

SATURDAY 18th July 1953

Made breakfast and took mine upstairs to the bedroom to eat alone as G. and I weren't friendly. Didn't let him kiss me goodbye. Met Betty Key at half-past ten and had coffees in Collinson's, asking her advice. Walked home. Granville had come back from work—OK with him again.

SATURDAY 18th July 1953 (Continued)

To the library this afternoon. Evening, extremely upset because all the cakes I baked went wrong. All because of the foul kitchen.

SUNDAY 19th July 1953

Morning, still in bad mood. Jeanne and Norman here for tea.

HOUSEWIFE'S HINT

A heavy crop of runner and French beans is worth storing, using 1 lb of cooking salt to 3½ lbs of beans. Use an earthenware jar and press alternate layers of beans and salt down well. Add more from day to day, and when the jar is quite full cover to make it air-tight.

Holidays are near. If you are going to keep your daughters in cotton frocks you will always be ironing. Shorts and shirts are much more practical. You might make a few sunsuits from discarded cotton frocks—seersucker for preference.

MONDAY 20th July 1953
Walked to town full of determination to act upon decision to get a streamlined, modern kitchen. Put an advert in the *Examiner* newspaper office to sell the house. It cost 7s. Walked home, slightly apprehensive. Washed and ironed. Read in bed this evening.

TUESDAY 21st July 1953
Washed cellar floor, pasted wallpaper by the sink to try and make it look more enticing for a prospective buyer. Painting the cellar walls. Then cleaned small bedroom. We went to Philip and Edith's after tea. Silly game of cards, supper.

WEDNESDAY 22nd July 1953
The worst of having a house for sale is that it's always to look at its best. Polished the furniture and cleaned living-room, including all the woodwork. To the library for 5 p.m.

THURSDAY 23rd July 1953
Hardly dare go into *Examiner* office in case there were—or weren't—any replies to the advert. There were. Lunch with Granville in Ritz café. Bus to mother's. They had gone to York for the day, a note was left on the table. Christine, Syd's niece, was in charge of Major. We all went for a walk up the fields. Then I went to the library.

FRIDAY 24th July 1953
To the library for afternoon session. Mr Amey left at 4 p.m. so I had tea by myself. Then locked up while I went for a walk round the village. Very busy during the evening library session. Home on the 8 p.m. trolley bus.
 Granville is on holiday now from work for a fortnight. He washed the bathroom ceiling.

SATURDAY 25th July 1953
10 a.m. at Golcar library until 12 noon. Granville called for me there and we walked to his mother's for lunch. Then I went to Slaithwaite library 2 till 4 p.m. Back to his old home for tea. In the evening we went to the Ritz to see *Cosh Boy*. Walked home.

SUNDAY 26th July 1953
Cleaning stairsteps, landing, and cellar with Granville. To mother's but all out. On to Betty Key's. Stayed for supper.

HOUSEWIFE'S HINT
Blackcurrants and redcurrants should be made into jam and jelly now. Bottling continues and store cupboards begin to fill up which is very satisfying to the housewife with squirrel instincts!

Herbs should be dried as their flowers begin to open. Plan some expeditions as high spots of the holidays, and lay in some supplies in case of wet days. Gum, paste, and balsa glue, brown paper and cardboard, powder paints and a hoard of bits of wood, wire, date boxes and scraps of material will all be useful.

MONDAY 27th July 1953

Just began washing when a storm broke. Poor Granville at home on his fortnight holiday. Jeanne and Norman called this afternoon. Then Granville limed the coal cellar. 5 till 7.30 p.m. working at the library, home on 7.45 bus. We listened to a play on the wireless, then to bed reading.

TUESDAY 28th July 1953

On the bus to Leeds with Granville. Lunch in Fields café there. Then rowing on the lake in Roundhay Park. Reminded me of courting days at Southport. Bus to Huddersfield, tea in Whiteley's café. On to mother's.

WEDNESDAY 29th July 1953

Granville had to go to the infirmary, something in his eye. I had muffins and coffee in Collinson's café. Walked home. An estate agent called. Working at the library from five.

THURSDAY 30th July 1953

Up at 10 a.m. Granville stayed in bed till twelve. We walked via Crosland Moor to mother's for tea. Then I started work at the library. Granville called for me and we came home on the trolley.

FRIDAY 31st July 1953

To another estate agents, George Booth's. Coffee in Sylvio's. Mr Myers drove us back home and measured up our house. Felt a bit mean when he did that, after all the house probably looked forward to us living there—and thought we would all be happy together. Felt a bit like crying, turned away to wipe my eyes. To Wheelers' for our dinner. Then walked to the library along the canal-side. How depressing canals are! Miss Firth with me this evening. Granville called for me when the session was over, and to his mother's for supper.

The
Diary *of a* Young Wife
1953

∽ AUGUST ∾

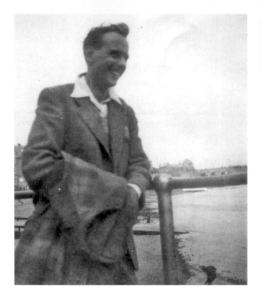

A brief holiday with Granville, raincoat over arm.

Granville sunbathing. They didn't know about the sun's rays being harmful in the 1950s and it was heaven to lay in its full glare, for once without a care in the world.

SATURDAY 1st August 1953

Mr Myers took us to see a house at Crosland Hill in his car. Town, Fields café. Home for lunch. Golcar library until four o'clock. Granville went to a cricket match this afternoon. I had tea with mother. Granville back when I returned, ironed, then we packed clothes for Southport.

SUNDAY 2nd August 1953

On 7.45 a.m. train to Southport, arrived 10.15 a.m. There were hardly any vacancies—we hadn't booked—but at one private hotel Mr Ballinger said we could sleep in the bathroom. It cost less, so we agreed.

Walked round in the afternoon and on the sands. Rowing on the lake in the evening, then to see the film *Snows of Kilimanjara*. It feels lovely to be having a real holiday and not making meals down in that awful cellar kitchen.

HOUSEWIFE'S HINT

Fairs and hot sunshine are what we hope for! Or stretches of untrodden sand, and a sea so warm we can be in and out of it all day.

Failing such pleasures, we make greengage jam, allowing ¾ lb sugar to every pound of firm, ripe gages. No water. Stone the fruit, bring to boiling point, remove from heat and add sugar. Stir till it dissolves. Boil quickly for fifteen minutes.

MONDAY 3rd August 1953

Granville's dark skin is tanned already, he reminds me of a combination between Ronald Colman and Errol Flynn. He adores rowing on the lake so we

spent the morning doing that. It was so hot this afternoon that we just relaxed on the sands. Had iced meringues in a café. Rowing again in the evening and looked round the pleasure ground. Granville went down the big helter-skelter, all dressed up in his wedding suit.

TUESDAY 4th August 1953

Rowing. Saw Mr and Mrs Blackwood, who sit at our table at Mr Bellinger's. Had coffee with them. They paid. In the afternoon we went to the pleasure fair with them. Granville, Nancy and her husband and I all came down the helter-skelter together. Evening, rowing again on the lake. Looked round the shops—best time when they are closed (when we have no money left). Listened to the wireless back in the private hotel, then Mr Ballinger played the piano and sang.

Catari was his party piece, and I asked him to sing it over and over. Our last night sleeping in his bathroom—it has certainly inspired us with passion!

WEDNESDAY 5th August 1953

Last look round Southport before breakfast.

On the ten o'clock train to Manchester. Lunch there. On the 1.45 p.m. train to Huddersfield. To Mrs Wheeler's for tea. Working at the library at 5 p.m. There were 209 book issues. Luckily Miss Firth helped me to put all the books away. Mother's for supper.

Gran. and I consoled ourselves with the thought that our summer holiday may have been only brief and now it's over—but we can now concentrate on selling the house and finding one with a proper kitchen before the winter.

THURSDAY 6th August 1953

Washing, ironing, cleaned the bathroom. Granville washed the sheets by hand in the cellar sink. He now realizes how hard it is doing that, down there.

THURSDAY 6th August 1953 (continued)

Library at 5.00 p.m.—200 issues. There until the 8.45 p.m. trolley bus, so busy shelving books. Read in bed.

FRIDAY 7th August 1953

Cleaned the living-room with Granville. 1.30 p.m. began work at the library with Mr Amey until 7.45 p.m. Granville called for me. Feels a bit like olden days when I see his suntanned face appear round the library door—as though we still are only courting and not burdened with a house and mortgage. To mother's for supper.

SATURDAY 8th August 1953

Baked cakes, washed clothes. P.M. to the library. A customer, old Mrs Lockwood, brought me some jelly and custard in a dish and home made jam

tarts at four o'clock. Granville went to the infirmary to visit his twin sister Margaret, in with one of those complaints that aren't discussed. Not in their family, anyhow. I don't know what the matter is. Then we went for a drink in the West Riding pub. On to the Curzon cinema to see *Stalag 17*.

SUNDAY 9th August 1953

2.30 p.m. visiting Margaret with Granville in Ward 10. Found it awkward knowing what to talk about, not knowing the nature—or severity—of the complaint. To Betty's for the evening, where we talked until 11 p.m.

> HOUSEWIFE'S HINT
>
> Have you tried drying plums? Make trays of fine wire netting tacked to old picture frames small enough to go into the oven. Stone the ripe fruit and spread out on the trays. Put in oven, starting at a temperature of 110° f. Raise to 160° f after three hours, and an hour later raise to 170° and continue drying till plums shrivel but are still soft. Do not over-dry. Take from oven and leave in ordinary room temperature for a week to soften (but cover to keep off dust and flies.) Pack in jars and seal.

MONDAY 10th August 1953

Wrote to Mr and Mrs Wheeler who are in Blackpool. Baked a cake and tidied up. Took some jelly and cake to the infirmary for Margaret. Walked home, met Mrs Lockwood. Sat outside. Harold, the lodger next door, invited me in to watch television. Mother came for tea. Mrs Lockwood recited for us.

TUESDAY 11th August 1953

Washed and ironed. To mother's. Lounging on her lawn. Walked home for tea. Darning socks sitting in front room with Granville.

WEDNESDAY 12th August 1953

Shopping in town. Mother's for dinner. Sat on lawn talking with her all afternoon. Auntie Annie to our house in the evening. She hopes we don't lose money selling the house. If ever we get a customer for it.

THURSDAY 13th August 1953

Full of energy. Cleaned bedroom, bathroom and all the shoes. A neighbour who lives opposite asked if I had any books or magazines she could borrow. In a panic as her husband has had T.B; didn't want to lend books as they would have to be returned—probably with germs on them.

Found all the magazines I have and took them across. I felt like running when she made me sit opposite her husband but politeness made me make conversation. To mother's for tea. Kept asking her if she thought I would get TB. She didn't, but looked worried. And suggested I make some excuse another time. Kept trying to breathe out all the air I'd taken in this morning, and breathe fresh air in. Took Major for a long walk.

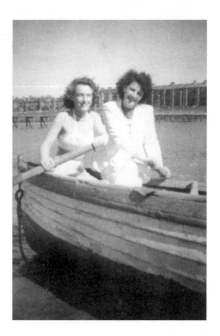

Hazel and her mother Hilda on
holiday in Morecambe.

FRIDAY *14^(th) August 1953*
Washed and ironed. Walked to mother's (so I could read undisturbed by my
neighbours) on her lawn. Evening, wrote an article.

SATURDAY *15^(th) August 1953*
Shopping in town. On the 11.45 a.m. trolley bus to see Margaret, now back at
her home. Helped cut their lawn. Margaret was moaning and groaning, telling
G. what to do all the time. So we made an early retreat home. Then went to
the Majestic after tea to see *Come Back, Little Sheba*. Felt mad because I can't
afford to array myself in lovely clothes like the film stars do.

SUNDAY *16^(th) August 1953*
Baking this morning as Betty, Norman, and their two and a half year old Julia
coming for tea. My heart was in my mouth as the furniture and paintwork was
kicked ruthlessly by her. Typed article after they went.

HOUSEWIFE'S HINT
Apricots are ripe and are lovely bottled or made into jam, using 4 lbs apricots,
4 lbs sugar, ¾ pint water, Stone the fruit. Break some of the stones and put the
kernels into boiling water so that you can skin them. Add to the fruit and bring
to the boil slowly; then simmer till the fruit is tender. Remove from heat and add
sugar. When dissolved, boil until set.
 1 lb. dried apricots, soaked in 3 pints of water, make a good jam if added to 5
lbs cooking apples stewed in 1 pint water. Add juice of 3 lemons and 5 lbs. sugar.
Boil for 15 minutes until set. (This jam is liable to burn.)

MONDAY 17th August 1953
8.30 a.m. bus to Blackpool to help G.'s parents bring their luggage back. We met them on the North Pier at midday. To their boarding house for lunch. Sat on a seat looking at the sea in the afternoon, then walked to Central. On that pier. Tea in Savoy café. Granville and I paddled in the sea then had a ride on a donkey each before leaving Blackpool at 6 p.m. We walked home from town after leaving the luggage and Mr and Mrs W.

TUESDAY 18th August 1953
Took G.'s breakfast to bed. Then we went to town and I bought him some brown corduroy trousers (cost £2). I want him to look like an artist, but he refuses to wear one of those silky knotted scarves. Coffees in Whiteley's. Home and began writing a story. Granville listened to a cricket match on the wireless. To Auntie Ella's after tea to watch their television. Walked home.

WEDNESDAY 19th August 1953
Typed letters to magazines—hoping to earn some money back for what I've spent on the trousers. Mother to the doctor's this afternoon to have ears syringed.

THURSDAY 20th August 1953
Sorted some of my old clothes out to give to Christine. Cleaning and polishing furniture. P.M. shopping then to Auntie Annie's for tea. Granville went there straight from work. Talking, and supper there. I pushed a note through Jeanne's door on the way home. Daren't go in, haven't been there for so long.

FRIDAY 21st August 1953
Polishing again in case any prospective customers show up. Walked to town, lunch in Collinson's with Granville. Called at George Booth's to see if there had been any enquiries about the house, felt depressed when he said there haven't. Finished shopping, my shoes felt to have lead weights in them I was so downhearted. Walked home.
 Might have shown myself up bursting into tears on a bus.

SATURDAY 22nd August 1953
Baking. Decorating cakes. A letter arrived from Mr Amey, asking me to go to Golcar library. Went there after lunch till four. Felt very tired and depressed when knitting in the evening. Granville just sitting—wireless was poor. Stormed off to bed, crying.

SUNDAY 23rd August 1953
Tidying house, preparing meals. Darning socks. Gran. reading papers. Mr and Mrs Wheeler and Margaret came for tea. Mr Wheeler and Margaret took it turns to have baths. They have to use a big tin bath from the cellar at their

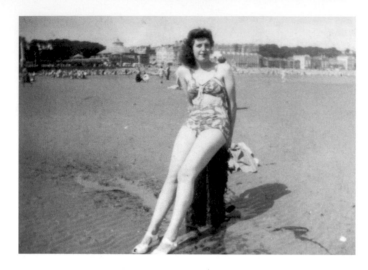

Hazel's friend
Jeanne Wood.

house, still have no bathroom. At least we have one of those. Temper vastly improved at the thought of how some people are even worse off than us. Bathroom-wise anyway. We talked in the front room till they left at nine.

HOUSEWIFE'S HINT
Paper-white narcissus should be planted this week if they are to flower at Christmas. They soon sell out in the shops so don't miss them. Other bulbs for house and garden should be ordered.

Winter clothes are the last thing you want to think about, but it might be as well to look at them in case of moths, and to send to the cleaners any you hesitated over in the spring.

MONDAY 24th August 1953
6 a.m. washing clothes. Cooked breakfast, ironing.

MONDAY 24th August 1953 (continued)
Jeanne called. I couldn't help crying as I talked with her. If I were to have a baby we should be in an awful financial position. Besides, I'd feel ever so self-conscious walking about like that. Jeanne is so big now. To mother's to cry a bit more. Then to the library, to laugh with Mrs Denny about it. Very busy. Pushed all thoughts of the cellar, future babies, out of my mind. We finished at half-past eight.

TUESDAY 25th August 1953
Morning, baked a cake. Felt a bit 'queer'—sickly. Walked to town, shopping, walked to Betty's. The kid, Julie, puts me off children more than what I already am. At nearly three she still wears nappies, and Betty is forever looking down them to see if she has been 'dirty'.

She was, a lot! Edith and Philip to our house in the evening.

WEDNESDAY 26th August 1953

Cleaned oven, bedroom, the windows. Walked to Crosland Moor then down the fields to mother's. Played with Major in the field. Library. 140 issues. Left at 8.30 p.m.

THURSDAY 27th August 1953

Cleaned front room and bathroom. Walked to mother's. 5 p.m. to the library. Home on 7.45 trolley bus. Pretended to Granville that I had been to the doctor's about feeling sick. He was very excited. If ever I did go, he wouldn't believe me, the times that I've pretended to him!

FRIDAY 28th August 1953

Cleaned the living-room, on hands and knees giving linoleum a thorough wash. Started work at the library at two, with Miss Firth. Had some fun when the lights fused. Neither of us knew how to mend them—and I certainly daren't.

SATURDAY 29th August 1953

Jeanne called, to 'see if I was' I think. Walked to town, walked back, heavily laden with shopping. Pouring with rain all day. 2 till 4 p.m. at the library.

SUNDAY 30th August 1953

Granville stayed in bed till dinnertime. An ordinary day—called to see mother, on to Wheeler's for tea. Out for a walk, home on 9.30 trolley.

HOUSEWIFE'S HINT

This is the time to call in gas fitters and electricians if any equipment is faulty—and have you looked at the flexes lately? It is easier to get hold of workmen now than later on. Really old gas or electric equipment is uneconomical to run, and you would probably save by renewing it. Visit local showrooms and see what is new.

Make the most of fine weather, and do a minimum of housework. Harvest the onions if their tops are yellowed.

MONDAY 31st August 1953

6.30 a.m. washing. Have to get it out early, or it would never dry, having to wring it all by hand. Granville staying at home, a bad cold. Ironed, and typed an article which I'm sending to the *Sunday Chronicle*. 5 p.m. at the library with Mrs Denny. Home on 7.30 bus. Took soup upstairs for our suppers. Listened to the wireless in bed with Granville. Pay for the month at library: £10 5d, less Nat. Ins 1s 3d—£9 19s 2d.

The Diary *of a* Young Wife
1953

SEPTEMBER

TUESDAY 1ˢᵗ September 1953

Received a guinea from *Woman's Illustrated*. Betty and Julia came this afternoon. Mother also. Julia crashing the furniture around again, relieved when they left. Told mother I may be having a baby. I upset everyone, including myself. She knows what an awful position we are in regarding the house—doesn't know how I'd go on having a baby to see to as well as the cellar business.

WEDNESDAY 2ⁿᵈ September 1953

Took Gran.'s breakfast to bed. A dustbin man dug some potatoes out of the back garden for me. I'd started to, but daren't touch the worms. There seemed to be such a lot of big fat pink ones hanging on for dear life to the potatoes. Washing up in the nasty dark cellar then cleaning the living room before going to the library for the five till seven session. Reading in bed when I came home.

THURSDAY 3ʳᵈ September 1953

Shopping in town with Granville. Lunch in Whiteley's. Reading *Who Lie In Goal* till time to go to the library.

THURSDAY 3ʳᵈ September 1953 (continued)

Granville went to mother's. It doesn't matter about giving a cold to her—only to his colleagues. At the library a college boy stayed helping me to shelve books. He's always coming in and hanging round me. He's very handsome, and gentlemanly manners. Didn't his face drop when I told him I was married! Secretly I felt a bit annoyed that I might be having a baby too. How will I ever be able to flirt again, looking like that for nine months?

FRIDAY 4ᵗʰ September 1953

Dusting. Granville cleaned the bathroom linoleum. To Mrs Wheeler's for lunch. Then at the library with Mr Amey till 8.45 p.m. trolley. Mr Amey got some books out about pregnancy while we were having tea, to try and decide if I am or I aren't. I have felt sick nearly all day.

SATURDAY 5ᵗʰ September 1953

Took case full of our clothes to mother's. Staying there with Major while they are at Blackpool. Granville went on to the fish and chip shop for dinner, bringing one back for Major.

2 till 4 p.m. at the library. I kept flying outside to children (horrible ones) who were tormenting a cat. Granville had been in bed when I returned. Tired, worried.

SUNDAY 6ᵗʰ September 1953

Took Gran.'s breakfast to bed. Baked cakes and cooked dinner. In mother's kitchen, on the level. Grand not having to run up and down cellar steps. Philip

and Joan Garside came for tea. Joan and I were playing hell with the men because it's women who have to have babies.

HOUSEWIFE'S HINT

Second early potatoes must be dug, if the skin is firm when rubbed. Choose a sunny day so that the crop can be dried before being stored in a cool dry place, well covered so that the light does not turn them green.

Suitcases, finished with for this season, should be put away with locks oiled. If you are systematic you will put in them the lists of holiday needs you found so useful. If you are not—well, it was fun buying forgotten essentials in strange shops.

MONDAY 7ᵗʰ September 1953

Feeling very worked up, I went to see Doctor Gilmore. Granville came with me. He says it's early yet to say if I'm having a baby. I went blackberrying afterwards with Major. Felt very sick all day. But cooked dinner and baked a pie. Washed clothes then sat out reading the papers. 5 p.m. to the library with Mrs Denny. Crying when I reached 'home'. Feel awful.

TUESDAY 8ᵗʰ September 1953

I know very well this is all through sleeping in Ballinger's bathroom at Southport. feeling free and easy, and nothing to worry about while away from the cellar. Feel sick again. Called at our house to see if, by any chance, we've won a million pounds or anything like that. When I returned to mother's I didn't feel well so went to bed. Cried when Granville came back after being to see his dad.

I'd put baby clothes out for him to see, that Syd's first wife had knitted and bought for the baby she was expecting. She had pernicious anaemia, and both she and the baby died. Think that could be why my step-father is often morose looking. Never having had any family. At first, I vowed if ever I had any children, they wouldn't call him granddad. But I want it to now. Poor Syd. And that poor baby, who never lived to wear the cuddly fluffy pink romper outfit, and other things. Mother says that I can have them for my baby, if I ever have one.

After Granville had looked at them sadly, I made him put them away in the tissue paper in the drawer. They suddenly seemed as though they might be an ill-omen.

WEDNESDAY 9ᵗʰ September 1953

Awful sickly sensations again. Baked a pie, then to the shop. Reading all afternoon and trying to forget what I feel like. Very busy at the library. Jeanne and Norman came for the evening. Envying Jeanne now—she's so much nearer having her baby, getting it over with. I'm just at the very beginning—

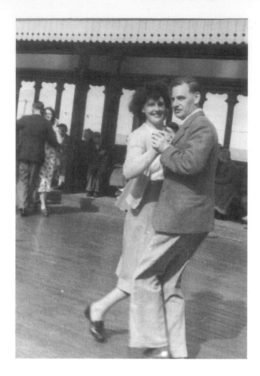

Who one encounters at a dance may make, or mar, one's life! Hilda changed her name to Margaret when she married Syd, not to be confused with his sister Hilda.

THURSDAY 10ᵗʰ September 1953
Took Major to our house to see if there has been any post. Bought fish and chips for my dinner from local fish and chip shop. Reading *Sally Scarth* (by Naomi Jacob). Began working at the library at 5 p.m. Granville and Major met me later. To bed early but didn't feel so bad as yesterday.

FRIDAY 11ᵗʰ September 1953
Felt sick at first, it passed off soon. Tidied the house before going to the library, afternoon session with Miss Firth. Mr Amey phoned us. Poor Miss Firth got into a terrible mess telling about two persons—borrowers—Hodgson and Pogson. Trying to explain about them she got all flustered, much to my amusement. Home on 7.45 bus.

SATURDAY 12ᵗʰ September 1953
Blackberrying then baking. 2 till 4 p.m. at Golcar Library. Granville went to a football match. Mother and Syd back about seven. They had words with their next door neighbour Mr Pearson, because he had chopped their trees down. Pearson is a bee keeper, so they had to be somewhat careful. Granville and I slept in my former single bed together.

SUNDAY 13ᵗʰ September 1953
 After breakfast in bed talked with mother. Eric brought her some washing to do for him. I felt awful when packing to go back to Fenton Road and the

cellar kitchen again. And it made me feel quite sick again, also sorry to leave mother and Major.

HOUSEWIFE'S HINTS
Tomatoes are in good supply. To bottle, dip in boiling water and remove skins. Cut in half and pack tightly in bottles, with ½ teaspoonful of salt and the same amount of sugar. Press down until the jar is full, but add no water.

Peaches can be skinned in the same way, then cut in halves or in slices and packed in jars. Cover with a syrup made by dissolving 4 tablespoonful of sugar to 1 pint of water.

MONDAY 14th September 1953
Washing down in the cellar again, and dreading hanging them out because I can't bear the neighbours wasting my time talking. Wondered whether to hang them in the cellar, but it was fine, so very quickly and nervously I slung them over the clothes line any old how as long as I could dash back inside unnoticed. Called at Jeanne's, then to mother's for dinner. Tea there before going to the library. There with Mrs Denny. She agrees with me what a pity it will be now that I have work that I enjoy, if I am having a baby and will have to give it up.

TUESDAY 15th September 1953
Properly sick in the bathroom after Granville had gone to work. Retching so hard felt that any baby in my stomach must surely be sea-sick. Wrote to Mavis. Walked to town, glad to be meeting mother at half-past eleven to tell her about being sick this morning. We enjoyed ham sandwiches and coffee in Fields café. Then to the solicitor's about the trees being unlawfully cut down while they were away.

TUESDAY 15th September 1953
Then to George Booth's, estate agents. Home. 2.30 p.m. felt limp, to bed for a short while. To the Plaza cinema with Granville in the evening. Jeanne and Norman came with us. The film was called *Never Let Me Go*.

WEDNESDAY 16th September 1953
Still feel sick. Cleaned the bathroom, thought it the best place to clean when feeling like that, easy to hang over the sink if necessary. To local grocer's at bottom of the road with our grocery order. To mother's. We went blackberrying. Library 5 till 7.30 p.m. Granville has a bad cold again, we read in bed.

THURSDAY 17th September 1953
Granville stayed in bed. When a man is ill, he can stay at home and be looked after. But if I'm not well I've to hurry to make his breakfast and pack his dinner. I cleaned living-room and polished the Welsh Dresser suite. I do like

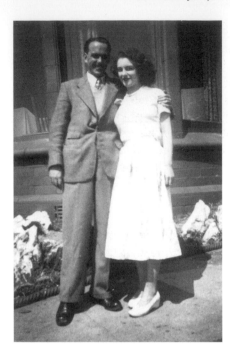

A film called *Escape me Never*—Granville putting it into practice with Hazel?!

it, cost us £32 from Taylor and Hobson's 'utility' furniture. Finished reading a book, *White Wool*, before going to the library.

FRIDAY 18*th* September 1953

9.30 a.m. To see Doctor Gilmore. I had to wait till the others had been attended to, then had to go into a small room. Had to undress and lie on a high table. Didn't like the internal examination, then he took my blood pressure. Then he explained all about having a baby—after telling me that my baby would be born either the end of April or beginning of May.

FRIDAY 18*th* September 1953 (continued)

I had the usual reaction—tears—the news, though expected, overwhelmed me. To mother's straightaway. She immediately made coffee and fussed around me. Just what I needed. We were soon giggling together. Library later with Mr Amey, then to Jeanne's to tell her.

SATURDAY 19*th* September 1953

Morning, shopping in town with Granville. Lunch in Ritz café then I went to the library. Granville went home. Jeanne and Norman here in the evening. I was very annoyed with J. when I said that the cellar was a B—nuisance, she, in her most clever manner, said it was 'just my attitude of mind'.

I'm not *imagining* that I have to go up and down stone cellar steps every time I want to even put the kettle on.

SUNDAY 20th September 1953

Morning, both Granville and I were bursting with the news about the expected baby when we went to his mother's. Granville said 'you are going to become a grandmother in April'. And I promptly began to cry, as though I'd committed some heinous, reprehensible crime. G.'s dad simply said 'oh' in an unemotional tone of voice, and went on reading his paper. Was very glad to get away. We went to mother's. Even Syd had a gleam of delight in his eye and looks to be viewing with pleasure the idea of being called granddad. Even if he wasn't lucky enough to ever be called dad. We went to Betty's for tea. Then played draughts.

> HOUSEWIFE'S HINTS
>
> A quick way to peel a tomato is to spear it on a cooking fork and hold it over the gas flame. It splits instantly, and the skin is then easy to remove.
>
> Indoor bulbs should all be planted now, except crocuses which can wait till November. Remember to plant hyacinths in a bowl deep enough to take a twig later on for support. Otherwise the flowers fall over when in full bloom, and frequently lift their bulbs from the soil or fibre.

MONDAY 21st September 1953

Read Sunday papers that I hadn't time to read yesterday. Washed clothes. Ironed before going to the library. Mrs Denny with me this afternoon. Home on 7.30 trolley bus. Edith was waiting to talk to me when I arrived home. Bubbling over with excitement, talking about maternity homes and having babies.

TUESDAY 22nd September 1953

Received a cheque from the *Nottinghamshire Guardian* for an article I sent them—about grown up men always wanting to read library books about cowboys and Indians. My very first article accepted at last! Went upstairs, so happy, and said my prayers, kneeling down by the side of my bed. Thanking God for giving me the ability to write and earn—full of hope now that having a baby will not entirely stop my earning any much-needed money. Shopping in town. Into Sylvio's café for scones and coffee—couldn't face my usual meringues. Left 3d tip as I felt so rich and so happy. Saw and talked with lots of people, including Mr Adkins, who encouraged me to apply for membership of the Authors' Circle. Auntie Annie came for tea—and two people came to look at the house.

WEDNESDAY 23rd September 1953

Mending Granville's socks and cleaned bedroom and bathroom. To mother's before going to the library, finished 7.30 p.m. Home on bus, listened to the wireless and read in bed.

The FIRST BABY

*It is not only new mothers who will
find these suggestions helpful*

Choose your doctor with care, for much of your peace of mind depends on the confidence you have in him

HAVING a baby is an ordinary enough occurrence—unless you happen to be the mother. Then, of course, it becomes *the* event of the year. Whether the waiting months are to be happy or tedious depends upon your attitude of mind.

Do remember that pregnancy is not, in any sense, an illness. It is a perfectly natural process, and the majority of women discover that during this time they feel, and look, better than ever before.

The first thing you will want to know is the date of your baby's arrival. Take the date on which your last period started, and add nine months and seven days. For example, if your last period began on February 1, then you can expect him to arrive round about November 8.

But babies aren't always punctual! If you are going to a hospital or a nursing home, have your bag packed two weeks before The Day, and don't be surprised if you are still at home two weeks after it!

Friend Doctor

Choose your doctor carefully, making quite sure that he is interested in midwifery.

B.H.M.—19

Some doctors just aren't, and while you would still be in perfectly safe hands, you must be able to look upon your doctor as a friend.

Once there was an idea that the expectant mother should 'eat for two.' Now we know that this is completely unnecessary.

Eat, just as you always do, three normal meals a day. You need one to two pints of milk a day and plenty of fresh fruit, vegetables and green salad, butter, eggs.

It is essential to have your teeth inspected, for if any of them are decayed they will undoubtedly get far worse during the time you are expecting your baby.

Clothes are always a problem, for the nicer you look the better you will feel; and pay attention to your posture. Don't slouch or sag. Hold yourself as tall as possible, with your tummy muscles drawn well in, and you won't need those maternity clothes for quite a while.

When you do begin to get bigger, don't go straight into smocks. Choose a cross-over dress, preferably in a dark colour (navy blue is best) with white at the neck, and an expanding waistline, with a long cross-over collar.

THURSDAY 24th September 1953

Mrs Dyson[1] called me in to look at her new chairs while I was rushing round cleaning living-room. Damned nuisance. Delighted when Philip and Audrey came at 10.45 and stayed till twelve. Walked to mother's. Sat out in deckchair writing. Major still has a cold. To the library. The college boy put a lot of books away for me, from six until I closed. To the Wheeler's for supper.

FRIDAY 25th September 1953

Very sick in bathroom after Gran. had gone to work. Annoyed at that, he ought to see what it's like. I'd seen a slug and a spider in cellar when I was making breakfast. Think it was that that caused it. I wrote an article 'I was a Christmas Casual' and sent it to *Woman's Hour*. I felt sick all the time I was with Miss Firth in the library.

Home on 7.45 bus. Philip, Audrey and mother at house. Major very poorly, but still lovely and pleasant, wagging his tail valiantly. Can't bear the thought that he may be going in exchange for our baby coming—

SATURDAY 26th September 1953

Breakfast in bed. It takes having a baby for that to happen! To see estate agent. Mr Booth himself is coming.

SATURDAY 26th September 1953 (continued)

To the house on Monday. Went to the library 2 till 4. Home for tea, then to the Picture House to see film *The Triangle*. It looked as if Granville was staring at a woman opposite us. Pulled my hand away from his. Left him when we got outside. He followed me, saying lamely that he'd been watching what I was staring at—the trouble is, these days I'm too soon worked up. No confidence that he will still prefer me when I begin swelling up like a balloon.

SUNDAY 27th September 1953

Didn't feel well all day. We just had bacon and eggs for dinner. Bus to Beaumont Park. Had a walk in there then to mother's, and Mrs Wheeler's for tea. A boy called Rodney there, some relation or other. We played draughts. When he left Mrs Wheeler said she was going to buy us a pram. My grateful delight subsided when she said 'but not new'.

HOUSEWIFE'S HINT

This is tidying-up time in the garden. Pea sticks are stacked, unless they have any kind of disease, when they must be burnt. Burn too all woody stalks and stems, but compost anything green that will rot well. Don't be tempted to burn the leaves—they are much more valuable if composted.

1. Mrs Dyson: my next-door neighbour at Fenton Road

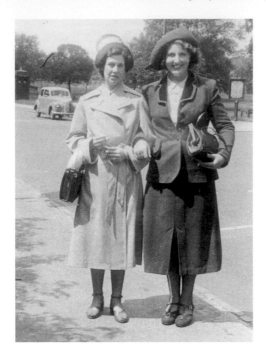

Auntie Ella in 1950s 'new look' outfit on holiday with a friend. Neither could walk comfortably in high heels but well dressed ladies were never without a hat!

Put away the garden furniture, making sure any canvas on chairs or shelters is quite dry. Smear grease on any tools put away for the winter.

MONDAY 28th September 1953
Tidied rooms. Felt lousy again. Washing in the afternoon then looked through *Writers' and Artists' Year Book* for suitable market to send my new article to. Listened to *Woman's Hour*. 5 till 7 p.m. at the library. Granville met me from the bus.

TUESDAY 29th September 1953
Still feel sick. To Doctor Gilmore's. All he said was 'you'll feel a lot worse before you're better!' To mother's. Terribly upset, Major is very weak, and lying on the couch most of the time. Went to town and bought a pair of fur-lined boots for wedding anniversary present for Granville. Coffee in Sylvio's. George Booth and another man came to value our house. I'm so fed up of it that I gave permission for them to sell it at £1,300. A loss on what we paid for it. Went to see Edith with Granville after tea.

WEDNESDAY 30th September 1953
Baking, then—unheard of for me—had a rest on the bed after lunch. Emotionally exhausted. Cleaned the bathroom, then to the library five until seven-thirty. Auntie Ella and mother here for supper. Auntie Ella gave me a bracelet, a bottle of peppermint (swears it will 'do the trick' and stop me feeling sick) and a tin of bacon.

The
Diary *of a* Young Wife
1953

~ OCTOBER ~

THURSDAY 1st October 1953
Couldn't wait until tomorrow to give Granville his present of boots and a card. Don't feel bad at all this morning, must be the pills the doctor gave me. Cleaned the living-room.

THURSDAY 1st October 1953 (continued)
A couple came to look at the house. Don't want it. Neither do I. To food office for orange juice and vitamins. Felt a bit out of place with another ration book.
 To mother's for tea. Mrs Wheeler here this evening and Norman called.

FRIDAY 2nd October 1953
 Our first wedding anniversary. In contrast to last year, it was a lovely warm, sunny Autumn day. How annoying. Cards arrived from the Wheelers, Annie, Edith and Philip. P.M. at the library with Pat. Granville met me afterwards. We walked to mother's—all out. Went to see Barbara. I sulked on the way back as we aren't getting rid of this lousy house.

SATURDAY 3rd October 1953
Nearly sick. Awful sensation. Wonder what I'd do if it happened on a bus, or when attending to someone at the library! Granville went for an interview at Crowther and Vickerman's. He doesn't seem to like the place. I went to the library then Granville met me in town. We had tea (chicken) in the Pack Horse Hotel. Then to the Picture House to see *Dangerous Moonlight*. Walked home. Cried in bed because I hate it here, in this house. Up and down the stairs every time I even have to make a drink of tea or coffee. And everybody who comes to see it will feel the same way, so how can we ever get rid of it?

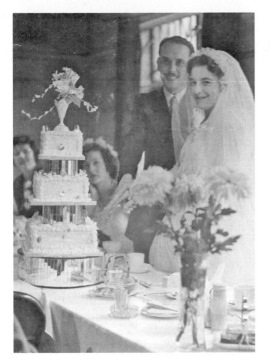

Top left: our wedding day, 2nd October 1952. *Top right* and *below*: my card to Granville on our first wedding anniversary. Another penniless year with no money for eternity rings or meals out (didn't want them anyway) but instead a wonderful day walking in the woods. Our boat was always rocky—often near capsizing—but no one else would do. Yes, I'd board that little ship all over again. Laughter was the wind in its sails!

I know two folk who sail life's seas

In a little ship for two;

And they are very happy folk

And shipmates staunch and true.

I'm glad that I'm one of them

And the other one is YOU!

To Gypsy,
On our first wedding
Anniversary,
Oct. 2nd. 1953
X All my love
Hazel.

SUNDAY 4th October 1953

A typically golden-red beautiful Autumn morning. We went on the bus to put chrysanthemums on dad's grave. Walked round the old lanes where I used to live. Back to town, milkshakes in the Arctic café. Then on bus to Mrs Wheeler's for dinner.

For a walk with Granville and Mr Wheeler on the canal side, most depressing, with mill chimneys towering all round. And weeds, and a dead dog lying floating on the canal—

Mr Wheeler didn't seem concerned about it in the least, which made me furious. I wanted one of them to dive in and retrieve it. Played draughts, knitted and kept on about the fate of the poor dog out there in the canal. With nobody to care about it, but I do.

HOUSEWIFE'S HINT

Study the lighting of your home with a very critical eye. Is it good enough, and do you want another lamp? Can you all see to read or sew, or must someone always be a martyr? Now is the time to put it right!

It is also the moment to make sure that the television set is in the best possible place—and to have it put right, and the wireless set too, if any adjustment is necessary.

MONDAY 5th October 1953

Morning, wrote and typed an article for the writing course. Washed and ironed. Walked over the fields to mother's. Both of us crying, Major on his last legs. He won't eat or drink and can hardly walk. He is looking at us with those deep brown soulful eyes, speaking his love with them.

MONDAY 5th October 1953 (continued)

Wished that I hadn't to go to the library, so that I could stay with Major. But had to go. Kissed his black, wavy Labrador head, silently praying God that he won't suffer long. And that he will take him safely to heaven, to wait for me there.

To town on the half-past seven bus after work. To the Fraternity Hall with Granville to hear the Co-op Choir, with mother, Syd and Christine singing in it. Some of the songs they sang—*Come to the Fair* and other lovely tunes made me feel heartbroken about Major, who will never be able to run in the sunshine again. Cried myself to sleep. Before leaving mother she murmured 'don't cry, Hazel'—while she was crying inconsolably herself.

TUESDAY 6th October 1953

Woke up, swollen-eyed. Nearly sick, it seemed to tear my inside apart. Ironed and tidied up, my whole mind with Major, up at mother's. A couple came to look round the house. Shopping, then, trembling with apprehension, to mother's.

The Co-op Choir—uniform delight! Even Syd was smiling (3rd left back row)!

My darling Petsy, Major, has had to be put to sleep this dinnertime. The vet came while I was there. We cried all day.

When Granville and Syd came back from work they wrapped his big beautiful black body in a yellow and white checked tablecloth, covered again with a flowered one. We could hardly bear to watch them carrying him up the steep garden path then laying him gently in the deep hole they had dug beneath the apple tree.

WEDNESDAY 7th October 1953

We didn't arrive home last night until 10.45 p.m.—a couple had been waiting for us to come back so they could look round.

They must have felt sorry for the state I was in, all puffy eyes and incoherent, as they were on the doorstep by eight o'clock this morning, asking if I felt better, and said that they wanted to buy the house: Contrary to what I'd imagined, I didn't feel at all excited. I'm too emotionally worn out for that. Went to a telephone box when they left to tell Auntie Ella about Major, she immediately burst into tears. Then to St. Luke's Maternity Hospital to book for going in next May. Walked to mother's, we had lots of coffee, looking out up the sloping back garden to where Major lies. To the library.

THURSDAY 8th October 1953

Re-wrote an article and typed it. On the trolley to mother's. Oh, the *hell* of only one of the two there to greet me. But I must go to relieve mother of the unaccustomed silence! To the library, Granville met me afterwards to go to his mother's for supper. Felt utterly exhausted. And they didn't help, either, by

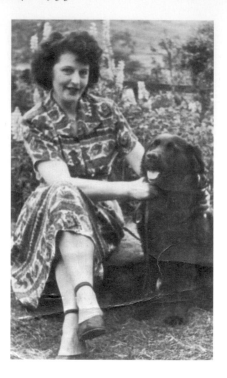

Above: another walk Hazel? Hazel's best friend Major—loyally come what may.

Right: Hilda (then Mrs Gregory, not Taylor) with the beloved Major. Both from the village shop to 41 Avison Road, Cowersley, Huddersfield.

saying 'you must think about the baby now, he was only a dog'. Only. Worth lots more than human beings, the way he loved and cared for me.

FRIDAY 9th October 1953

Baking this morning then to the library with Miss Firth. Didn't feel very well. And think I'll have to belt my navy and white striped tweed coat onto the next notch soon.

FRIDAY 9th October 1953

After the library closed I went on the bus into town—met Granville and to the Co-op film show. Mother and Syd were there. It was awful, we came out before it was finished. Mother certainly wouldn't have had anything to do with Co-ops if Syd hadn't already shopped there when she married him. When we had our own shop it would have been a heinous crime to even enter the portals of a Co-op!

SATURDAY 10th October 1953

Tidied the house. But not as bothered about doing so now that someone has bought it. Felt awfully sick. Was sick properly. What a waste of money, buying something for breakfast then wasting it all. Glad I'm not at the library in a morning, when I feel worse. There, two until four. Met Granville in town, to Auntie Ella's for tea.

Afterwards we all went to her friend Mrs Biltcliffe because she has a

Labrador like Major. Took it for a walk through the wood. Watched television. A band played *Auld Lang Syne* and Ella and I began to cry about Major. No words spoken between us, mental telepathy as the tune and words began.

SUNDAY 11ᵗʰ October 1953
Norman Brook, who has bought the house, arrived to measure up. He's going to have carpets all over apparently.

SUNDAY 11ᵗʰ October 1953
Auntie Annie arrived at 2 p.m. and came with us to mother's. All walked to Crosland Moor and called to see Cissie, a teacher friend of Annie's. Evening, talking round the fire. Annie more helpful about Major, says she's sure he's now with Jesus. And we'll meet again.

HOUSEWIFE'S HINTS.
Summer frocks, even if only worn once or twice, must be washed before storing, but do not starch them. Put them in your holiday suitcase, where they won't be in your way.

Make any alterations to your winter clothes before you begin wearing them. Once they become a habit you don't notice their faults. Have a dress parade with a fashion-conscious friend and see what can be done to make them look like new.

MONDAY 12ᵗʰ October 1953
10.30 a.m. had to fly upstairs to the bathroom to be sick. Life isn't worth living just now. Washed clothes. Ironed a few. I'd only had a bit of shredded wheat and it all came back. Feel utterly dejected. Had to look away as I swilled bits of fawn coloured wheat down the sink, or I'd have started all over again. To the library, taking a deep breath before I left the house and trying to calm my stomach. Barbara Mitchell and Winnie came to our house in the evening.

TUESDAY 13ᵗʰ October 1953
Edith called, to town with her. Met mother 11 a.m. All to Sylvio's café. Bought a loose, hip-length navy smock at Kaye's shop, but had to leave a deposit, not enough money to pay for it.

TUESDAY 13ᵗʰ October 1953 (continued)
To Hubert Armitage, estate agent. Felt sickly all day. Made up my mind that I shall never have another baby. Finished ironing when I came home, and stayed in knitting.

WEDNESDAY 14ᵗʰ October 1953
Granville brought my breakfast to bed. Doctor Gilmore says that if I have something, if only a biscuit, before my feet touch the floor in a morning it

should help. Felt tons better. Cleaned the bathroom—and dared to stand upright looking the sink in the face without having to double up over it. Walked jauntily over the fields to mother's. Then to the library, where we were very busy. Granville met me off the bus as it's dark now in the evenings. We listened to a play and I knitted.

THURSDAY 15th October 1953
Went down to Firth's, the grocer's, for some eggs. Baking, library this afternoon. Granville met me off the bus.

FRIDAY 16th October 1953
Baking. To Mrs Wheeler's for dinner, taking a cake that I'd made for the bazaar. Mr Amey with me at the library. When we were having our tea break he brought out a lot of medical books again and was giving me all kinds of information. Granville met me at the bus stop, home.

SATURDAY 17th October 1953
Shopping with Granville. Coffee in Fields café, could even enjoy two of their delicious little chocolate coated buns with a bit of green angelica on top, without feeling sick. Whereas before I felt like damning everything, now I feel like praising God for feeling alright.

Home for dinner, then to the library. Mother and Syd came for tea. First time without my Petsy. All to the Plaza to see *Captain's Paradise*. Mother and Syd back for fish and chip supper before walking home.

SUNDAY 18th October 1953
Baked a cake, cooked dinner. Lovely walk through Beaumont Park, Butternab wood, and Crosland Moor. Mrs Wheeler and Margaret came for tea. Listened to the wireless and knitted. Everybody seems mightily relieved that I'm not feeling sick so much, I was almost getting suicidal!

HOUSEWIFE'S HINT
To make an excellent filling for cakes, or a very popular spread for bread and butter, simmer a tin of sweetened full cream condensed milk for three hours (it could be cooked under the steamer when making a suet pudding.) The result is a thick brown cream with a very pleasant flavour.

Keep a wary eye on lofts, attics and store-rooms, because mice like to come indoors now, and can settle down comfortably in a very short time!

Dahlia roots should be lifted, dried and stored.

MONDAY 19th October 1953
My brother Philip's twenty-eighth birthday. Only had time to do part of the washing as I had an appointment at St. Luke's Ante-Natal Clinic. They had to lend me a dressing gown as, trust me, I'd gone in my short coat, and

Classic simplicity...

perfectly expressed in
NEEDLELOOM CARPETING

In the Hall

In Dining Room

In Sitting Room

In Bedrooms

In Hotels, Ships, Theatres
and other places

Luxury needleloom carpeting with a down-like welcoming tread and moth
and damp resisting impregnated rubber cushion backing. Tiresome under-
felts dispensed with. Elegantly suitable for fitted carpets, surrounds, etc.
Bulky sewing and binding no longer necessary with this simple to lay and
delightfully effective inexpensive carpeting. Colours—Rust, Forest Green,
Autumn Brown, Blue, Wine, Fawn, Grey, Old Rose.

STANDARD CARPET WIDTHS FOR FITTED CARPETS

17in. wide	26in. wide	35in. wide	52in. wide	104in. wide	
7/- per yard	**9/11** per yard	**13/11** per yard	**19/11** per yard	**45/-** per yard	Add 2d. per yd. for carr.

★ Also in SEAMLESS CARPET SQUARES. Cols. and Material as above

SIZES approx.	3 x 2 yds.	3 x 2½ yds.	3 x 3 yds.	3 x 3½ yds.	3 x 4 yds.	3 x 4½ yds.	3 x 5 yds.
	£4.10.0	£5.12.6	£6.15.0	£7.17.6	£9.0.0	£10.2.6	£11.5.0

Add 2/- part packing and carriage per Square.

★ SAMPLES of Carpeting and Squares 1/- Post Free
refunded if returned

RIDGWAY Stores

Carpet Division.

nighties we had to wear were slit open right down the back. Another internal examination and blood test. Neither pleasant, but I clenched my teeth and thought of animals in traps—such as poor little mice—so I wasn't going to be soft. To mother's, didn't arrive until half past four. A rush to get to the library. Later, Granville and I went to see a house at Birkby.

TUESDAY 20th October 1953
Walked to town, glad it isn't yesterday. Shopping, home for lunch. Scrubbing pans and cooking. In the evening we went to Jeanne's. She was very 'cocky' again—surprised at my going to St. Luke's. Thought I'd have gone to the Princess Royal. But as St. Luke's is within reasonable walking distance and on the same bus route, why go to the more prestigious Princess Royal—which would entail two bus rides? Also, Jeanne won't tell me anything about the actual birth, what it's like. Her baby, Dianne Elizabeth, was born last month.

I really thought I would get the truth about it from her, so still don't know what's in front of me. (Apart from a tummy that will grow increasingly cumbersome.) So upset I shouted at Granville when we were walking home, when he said he didn't see what I was making such a fuss about.

I bet he would want first-hand information, if it was him in this condition.

WEDNESDAY 21st October 1953
Wrote and typed an article. Walked over the fields to mother's for tea. To the library, home on the 7.45 petrol bus.

THURSDAY 22nd October 1953
Foggy. Feel depressed in a house on my own when it's like this. Especially as the admission card, plus two visiting cards arrived from St. Luke's. Printed on my card was:

This admission card is given on the understanding that you will receive adequate ante-natal care from a doctor between now and the date of admission. This can be received either from your own doctor or from one of the doctors in the Public Health Service. On admission Patients should bring with them if possible, Two Nightgowns, brush, comb, tooth-brush. A sanitary belt. (Optional) dressing gown and pair of slippers. No baby clothes required until patient is ready for discharge. Soap for mother <u>and</u> baby. Towel for mother.

Enquiries may be made between 9 and 9.30 a.m. or between 6 and 9.30 p.m.

VISITING HOURS. HUSBANDS ONLY. Every evening, 7.30 to 8. p.m. (In the event of the husband being away, the nearest relative may visit.)

Please bring your Ration Book and Points.

Sweet Coupons must not be brought.

Children under 14 years must not visit the Home.

The Visitor's Card to admit one visitor only. This should be the Husband, or if he cannot attend, one other person in his place.

THURSDAY 22nd October 1953 (continued)
It still seems all very unreal to me—as if it's either a joke, or a Big Mistake on their part. Washed towels by hand, wrung them out and hung them on line outside. On the trolley bus to mother's, then the library. To the Wheelers' for supper, talking with Gran.'s Auntie Nellie in her house before.

FRIDAY 23rd October 1953
Three months gone already, and no one can tell (if I didn't tell them) that I am having a baby. Only difference—my skirts don't fasten easily. Have to use a safety pin at the top sometimes. Library with Miss Firth. Looking at two houses afterwards with Granville. No good.

SATURDAY 24th October 1953
Baking then to local shop. Granville to work, then to a rugby match after dinner. I went to Golcar library. In the evening stayed in knitting and listening to the wireless. Bath, then reading in bed. (Not that I don't have many baths, I don't put them all in here).

SUNDAY 25th October 1953
Taken by surprise and disappointed when I had to lean over the sink heaving but not sick. Took Granville his breakfast to bed. Wrote an article. Rabbit and redcurrant jelly and vegetables for dinner. Walked to mother's, where we had tea. Stayed until 7.30, they were going out. Home. Feel fat. Reading.

HOUSEWIFE'S HINT
Quinces are ready for storing. Have you ever tried leaving one in your tea caddy? It gives a delicate flavour—but don't store it with your whole month's ration in case the family grow tired of quince tea!
For quince jam, peel 4 lbs quinces, core and slice. Bring slowly to boil with 4 pints water; simmer until tender. Pour in 5½ lbs warm sugar and stir. Then boil rapidly for 10 minutes or until set. Pot and cover at once.

MONDAY 26th October 1953
Breakfast in bed. Typed article. Washing. Mrs Denny with me at the library this afternoon. Home on half-past seven trolley. Granville met me. I ironed clothes while Granville washed the sheets, by hand in the cellar sink. He put buckets beneath them to catch the water, so they'll be ready to hang outside if it's fine in the morning.

TUESDAY 27th October 1953
Baking. Walked to town and met mother this afternoon. Wanted her to come with me to the Solicitor's about the house deeds. Then we did some shopping and I was home for half-past four. Edith and Philip here after tea, knitted and talked.

WEDNESDAY 28th October 1953

Dusted the bedroom, then to two estate agents in town. Nothing suitable- not in the price range we can afford. Bought a maternity corset. To mother's for dinner and tea before going to the library. A carpet traveller was the last borrower, then one lady came in, not to borrow a book but to see how I was getting on. The carpet man took me to the Wheelers' in his car.

WEDNESDAY 28th October 1953

It felt nice to vaguely be flirting again, but I was brought up to a halt in my mind when I remembered the huge pink, long laced corset lying in my shopping bag. If only he knew, I bet he wouldn't have offered me a lift.

THURSDAY 29th October 1953

Cleaned the bathroom. Walked over the fields to mother's. Felt like having some fresh air, so sat out on the lawn with my coat on, knitting. Mother kept fussing round, saying 'don't get cold'. To the library. Very cold in the evening. I waited ages for a bus. Granville was cold with waiting for me at the other end too. I sulked and cried when we got in. The whole position of houses seems lousy. Also told him how very much remiss his mother was for asking how much my corset was. Would she prefer me to eventually be walking about with my belly sagging onto the floor? To save money?

FRIDAY 30th October 1953

Scrubbing pans and other mundane jobs. In the afternoon at the library with Mr Amey. He brought me all the way home in his car. Very cold at nights now. Lovely to knit by the fire.

SATURDAY 31st October 1953

Town with Granville. Met mother. We signed deeds at the solicitors. Sinking feeling, not having anywhere else to go, now the so much despised house is sold at last! To Sylvio's for coffee and cakes and to try and talk out a solution. Home for lunch then Granville went to a football match. I went to the library. Mrs Schofield came in to talk to me. In the evening Gran. and I listened to *Saturday Night Theatre*.

The
Diary *of a* Young Wife
1953

❧ NOVEMBER ❧

safe as sunshine!

Accidents can't happen with Hurseal oil-filled safety radiators because heating elements are totally enclosed. Good-looking wall and floor models (some portable) available in many sizes and colours to bring gentle, healthy warmth to chilly nurseries, living rooms, bedrooms and draughty halls.

Hurseal are the original oil-filled heating units. Made from steel, they require no topping up and will give you a lifetime of comfort. Write for leaflets, or ask our representative to call. There is a permanent display of efficient heating equipment at 229 Regent St. (corner of Hanover St).

HURSEAL *heat*

THE **SAFEST** FORM OF HEATING

Oil-filled Electric, Gas and Paraffin Radiators; Televiewers' Comfort Heaters; Gas and Electric Towel Rails; Hot Water Radiators; Cylinder Insulating Jackets and Insulating Materials; Domestic and other Boilers; Inset Grates; 'Hurdapta' Fires; Electric Bed Sheets; Room Thermometers and Thermostats, and other fuel-saving equipment.

HURSEAL LTD., 229 REGENT STREET, LONDON, W.1. PHONE: REGENT 1051

SUNDAY 1st November 1953

Morning, read the paper and cooked dinner. To the Wheeler's for tea. In the evening Granville and I said we were going home but called next door to talk with his Auntie Evelyn and Auntie Nellie. Strange, but the more dire a situation is the more it seems to amuse them, they went into gales of laughter about my maternity corset—my thoughts about it—and descriptions of the foul houses we have seen. Felt guilty about not going straight home when we'd said we were, so returned to G.'s mother's to tell them we'd had a chat with the others. (They'd tell them in any case.)

HOUSEWIFE'S HINT
However much we deplore it, the shops will start Christmas displays this week. Take out your Christmas lists and see what you can make.

Gloves, hot water bottle covers, a bed jacket on thick pins, felt animals, aprons of all kinds—there is time enough to make these. Buy Christmas paper, labels and cards at leisure before the rush begins. Parcels for friends abroad should be packed now.

MONDAY 2nd November 1953

Typed an article. Washed clothes and ironed. On trolley to mother's for early tea before the library. Before Mrs Schofield called in, she's ever so considerate and worried about what we will do once the people move into our house.

MONDAY 2nd November 1953 (continued)

So she has been scouting round and says she has got us some rooms near hers in Slaithwaite. My heart sank, although I tried to smile and thanked her very much. Granville met me when I alighted from the bus. We hurried home to get warm, huddling over the fire. It's rained all day and was very cold in the library. Listened to a play, undressed downstairs in front of the fire before facing the cold bedroom.

TUESDAY 3rd November 1953

Walked to town. Met Edith, coffee in Collinson's. A lovely sunny day. Think the weather organizer, whoever it is, daren't put too many dark rainy days altogether, for fear the population would all go mad. Came home to iron and mend some clothes. In the evening to look at another house with Granville. Then we went to the Tudor cinema.

WEDNESDAY 4th November 1953

Tidied living room then walked over the fields to mother's. Our house doesn't feel like our house already, and I'm glad to get away from it. Syd came back unexpectedly, been to the infirmary after cutting his finger in a machine. He'll think I'm always there! Library. While there, Granville, mother and Mrs Schofield came in and we went to see the unfurnished rooms that she had

spoken to me about. Up at Bleak Hill Top, way on the moors. Gave me the creeps!

To mother's for supper, I wouldn't consider going there, in unfurnished rooms. How vile. But how to still keep friendly with Mrs Schofield?

THURSDAY 5th November 1953
After Granville went to work a letter arrived from Philip to say we can't go there for the weekend. Audrey's nerves are so bad. Extremely upset. Had been looking forward to having meals made, in a 'proper' beautifully furnished house, and long into-the-early-hours-of-the-morn conversations.

Wrote letters. Walked to town, putting replies to house adverts I've seen in the *Examiner*. Looked at magazines in the public library, tea in Heywood's, then to the library to work. Granville and mother came with me to see another house this evening.

FRIDAY 6th November 1953
Granville slept over, has food poisoning spots on his legs so he didn't go to work until afternoon. Well, they are some kind of spots, but he hasn't any pain. The man who has bought our house called, he and his wife stayed talking until nearly midnight. I almost envied them—having somewhere definite to live! I was at the library with Miss Firth this afternoon.

I was in a bad temper when I returned home, been frozen stiff.

Being in rooms in that locality would be a Death Knell.

SATURDAY 7th November 1953
Met Granville after he had been to work, also the Labour Exchange. Went viewing houses, lunch in Heywoods café. Also called to see the solicitor, we move out a week on Tuesday. Wonder if the couple who have bought our house will take temporary lodgers? Felt tired after listening to a play on the wireless, bed.

SUNDAY 8th November 1953
Syd's birthday. I took Granville's breakfast to bed. We're in an awful fix now, decided to risk asking mother if we could stay there until we get another house. But it's not as if it was dad. All the time I used to long to get away from Syd before I married Granville, how will he feel when I beg to go back again?

We'd only have a single bed to share, Granville and me, but at least it wouldn't be unfurnished rooms, and our furniture could be put in store. More expense, but unavoidable. I didn't broach the subject about staying there until I manoeuvred mother upstairs when I asked her what she thought. She is going to ask Syd. Didn't want to be there when she asked, so we went to see Betty. Granville was teasing me about 'not being the only pebble on the beach'—I scratched his wrists, felt like a wild fiend the way things are turning out. Probably only his idea of making light of the situation we find ourselves

in, but I *could* be if only I wasn't getting fatter with *his* baby. Feel so insecure about everything.

HOUSEWIFE'S HINT
A Christmas pudding; 1¼ lbs mixed dried fruit, ¼ lb plain flour; ¼ lb fine breadcrumbs; ¼ lb demerara sugar; ¼ grated nutmeg; ¼ teaspoonful mixed spice; 1 carrot or apple grated, 1 dessertspoonful stiff orange marmalade or grated rind of 1 orange; 1 oz. shredded almonds, 2-3 eggs; ¼ pint milk or ale; 1 tablespoonful rum or brandy; 4-5 oz suet.

Prepare and mix dry ingredients. Beat the eggs, add carrot or apple, marmalade, almonds, milk or ale and the spirit. Shred suet into flour before adding remaining ingredients. Boil or steam for 7 hours.

MONDAY 9th November 1953
Washed my boots, mending, washing and ironing. Library with Mrs Denny. Home. Helped Granville take the top from the Welsh Dresser and empty the cupboards.

TUESDAY 10th November 1953
Walked to town. Met Edith at 10.15, coffees in Fields café. She went home at eleven. To the Food Office for orange juice and—ugh—cod liver oil. Met Granville from work, lunch in Collinson's. Home, finished the ironing. A man knocked at the door, I have replied to his advert. Re-selling his house he said. He arrived at half-past three and stayed until nearly half-past five.

Evening, Granville and I went to look at another house. They wanted £1,700 for it. Back to town, then to see the house where my afternoon visitor lives. Don't like it.

WEDNESDAY 11th November 1953
Packing my writing materials and knitting patterns. Walked to mother's after dinner. Syd still there. He hasn't to go back to work yet. To the library. Granville and I listened to a play on the wireless later.

THURSDAY 12th November 1953
Packed some clothes ready for our departure. Straightened L. room up. Shopping in town, tea in Heywood's café before work at the library. Granville met me.

FRIDAY 13th November 1953
Morning, to Doctor Gilmore. Then mother's. Library with Mr Amey this afternoon. How I envy him—he has such a settled kind of life, nothing ever seems to ruffle him or things go topsy-turvy. I feel as though I'm hurtling towards a cliff top most of the time. Granville met me and we had supper at his mother's.

SATURDAY 14th November 1953

Granville went to town to get some tea chests to pack our belongings in. When he returned I was famished—sent him to the fish and chip shop, telling him to run all the way there and back. To the library this afternoon. Later to mother's. A crowd of their friends were there. At seven the men (including Granville) went out for a drink, and stayed for two hours. I was so angry that I threw a magazine at him when he appeared, all bright eyed, round the door.

He stayed the night, sleeping in my single bed. Don't think mother thought it would be safe for us to be alone together the mood I was in! It wasn't just the being out drinking, but a conglomeration of all the problems mixed up together.

But mainly that we now haven't our own house, and I am again under obligation to my stepfather.

SUNDAY 15th November 1953

Morning, we went back to Fenton Road. Philip arrived. Then Granville's dad came to help us pack and Jeanne called to ask us to be godparents. Back to mother's to sleep.

HOUSEWIFE'S HINTS

Clear gutters and drains of leaves and twigs to avoid flooding. Lag pipes and cisterns, and stop penetrating draughts in the house. Old sash windows often need a wooden peg to stop them rattling in winter.

If cold rooms and low fuel supply is your problem, why not convert your open fire into something which will give more heat and burn less fuel? There are several types of such fires on the market—your local dealer will advise you. No one who has enjoyed the comfort of such a fire—or of a continuous burning stove—will ever go back to the open grate.

MONDAY 16th November 1953

Back to our old house to wait for the gas man coming to read the meter. Back to mother's (hereafter to be referred to as 'home' again) at 11.30 a.m. To the library this afternoon with Mrs Denny. Granville went to do some more packing.

TUESDAY 17th November 1953

To Fenton Road. The electric man arrived. Granville at one o'clock. The new owner called. And the removal van didn't turn up till 3 p.m. by which time I had just left. To Annie's for tea.

WEDNESDAY 18th November 1953

Shopping and to the solicitors and estate agents. Just when life seems at a low ebb—no home of our own again—something turns up to make me optimistic about the future. A letter from the BBC. They like my script, 'I

Was A Christmas Casual' and would like to invite me to broadcast it on 14 December on *Woman's Hour*. Great, great thrill. Almost cried with happiness, flung myself on my knees upstairs, where no one could see me, to thank God. Can't believe that I will actually be heard by thousands of people listening in to the wireless. Can't wait to tell everybody either. Only wish I hadn't to go to the studios in Manchester wearing a maternity smock. To the library this afternoon, then to the Wheelers' with Granville for supper.

THURSDAY 19th November 1953
Wrote letters, on to the post office to buy a paper. Made a pudding for after our dinner. Afternoon, to town with mother. I lost her because she was in the chemist's when she should have been outside the bank. Furious. Tea and scones in Sylvio's by myself then to the library.

FRIDAY 20th November 1953
I have a bad cough and sore throat. Makes me sick when I'm coughing. Went to see Doctor Gilmore, and Syd went to the infirmary. Afternoon, writing and knitting. Then the library.

SATURDAY 21st November 1953
Very sick when having breakfast, I have a bad cold. I cooked dinner, in the afternoon Syd and Granville went to the football match. I went to the library. Made treacle toffee when home again. Then I had a mustard bath and went to bed early.

SUNDAY 22nd November 1953
Felt rotten with a wheezing chest, but cooked breakfast for us all. Don't want Syd to think me a nuisance living with them. Auntie Ella came this afternoon and went with the others to look at a house at Crosland Moor. I baked a cake and made tea. Bed early.

> HOUSEWIFE'S HINT
>
> A sowing of broad beans can be made in the garden now if your soil is well drained and fairly sheltered. Tidy gardeners will take down and stack the stakes of the runner beans.
>
> Indoors, make your mincemeat if dried fruit is available. If you live in a town it would be as well to order your Christmas Tree well in advance, so that you get the size (and price!) you want.

MONDAY 23rd November 1953
Doctor Gilmore came to see me. I have bronchitis. What a devil, just in front of a broadcast too. Stayed in bed all day reading. Finished knitting a baby coat. Slept a lot after tea because the light has no shade on, and is rotten for the eyes. Mother and Syd did our washing for us.

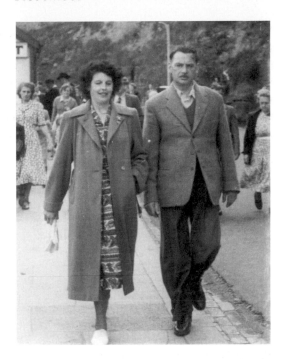

Mother and the ever morose looking Syd—even when on holiday!

TUESDAY 24th November 1953

Had a dental appointment, but couldn't keep it, or meet Edith in town. No telephone in the house, so couldn't let her know either, as they haven't a telephone either. Disappointed. Spent the day as yesterday, reading, only felt more dispirited. The sun never got out from the fog, and I had to have the bedroom light on about half-past three.

WEDNESDAY 25th November 1953

Stayed in bed again. Read *After The Funeral* by Agatha Christie. Lovely sunny sky so felt better.

THURSDAY 26th November 1953

Looked at magazines in bed. Wish I felt better so I could go out and feel the wind and sun on my face. Goodness knows how some people stick in bed for years. It must be hell. I'm sure that I'd rather be dead. Mother thought I'd be alright to venture downstairs for a short while after tea, so she wrapped a blanket round me for extra warmth while I listened to a play on the wireless. Enjoying it when my mother-in-law arrived unexpectedly! She was angry that I was downstairs. So was I when she arrived!

FRIDAY 27th November 1953

Doctor Gilmore called to see me. Says I can't get up until Tuesday. More than disappointed. Began knitting bootees for 'our baby'. A lady who works with

Granville sent me six bunches of purple pansies. Cried a little when he gave them to me, because I want to get up.

SATURDAY 28th November 1953

How irksome to have to stay behind in bed while Granville went to town. He brought me some magazines back. I was sick after dinner. Granville and Syd went to a match. Mother met Syd in town later to buy new curtains.

SUNDAY 29th November 1953

Granville up first, tidying up for mother. She was ridiculous enough to cook tea at half-past two, in order to have plenty of time to 'titivate' herself up for the evening. Both Granville and I are fed up of the outlandish mealtimes. I got up afterwards and sat in the front room darning Granville's socks. Then I was sick after supper.

HOUSEWIFE'S HINT

Tea-time comes into its own in winter, when hungry families love dripping toast, cinnamon toast or Scotch pancakes. To make these sieve together ½ lb plain flour, ½ teaspoon salt; 2 teaspoonsful baking powder. Make a hollow in the centre and pour in 1 well beaten egg. Mix gradually, adding enough milk (or sour milk) to make a thick batter. Grease and well heat a girdle or thick frying pan, and drop the batter on it in dessert-spoonsful. When bubbles appear, turn and cook the other side. Serve straight from the pan, with butter (and jam, if you feel extravagant.)

MONDAY 30th November 1953

Syd began working at David Brown Tractors today. I stayed in bed till three. Then in front room, knitting. Jeanne called with her baby, telling us when the christening is. Granville went to Doctor Gilmore after tea, to ask what I ought to do about going. He says that if I want to do the other job—the broadcast—I can't go to the Christening. Damn and blast—but I know which is most important!

TUESDAY 1st December 1953
Sick, and my nose bled after taking the medicine. Got up—legitimately, as this is Tuesday, when the doctor said I could do—and dressed after dinner. Felt very weak and sick. Wrote to Philip, then a story. Began knitting a jumper and listened to the wireless.

WEDNESDAY 2nd December 1953
Syd didn't go to work, there's an engineer's strike. Wish I was in a house of my own. Tried to write a story but can't concentrate when others are about. Gave up trying and listened to a play.

THURSDAY 3rd December 1953
Up at half-past eight. Wonderful! Wrote an article typed it this afternoon. Listened to *Woman's Hour*, marvelling that I shall be talking on it myself in a few days time. To the post office to post my article. Felt grand to be out even for such a short time. Spirits uplifted more when a letter arrived from Jeanne— she's postponing the Christening on my account! Looked at magazines with mother and Granville this evening.

FRIDAY 4th December 1953
To the doctor's. A paragraph I had written is in the *Examiner*. Typed a few more.

SATURDAY 5th December 1953
Had been looking forward to going to town, but it was foggy and raining, daren't risk getting more cold. Helped mother make the dinner instead. Reading with Granville in the front room in the afternoon. Mother and Syd went to the pictures after tea, Granville and I stayed in reading and listened to a play.

SUNDAY 6th December 1953
Granville to his mother's this morning. I had a good excuse not to go with him, bronchitis. Afternoon, Granville snored on the settee while I read magazines. In the evening a few members of the Co-op Choir arrived for a rehearsal and supper. Pleasant time.

HOUSEWIFE'S HINT
Winter spraying of fruit should be done on fine days. It is generally a cold and tedious job; the member of the family who tackles it needs sympathy and practical support such as hot drinks.

Marzipan fruits for Christmas can be made this week. For the basic mixture put ¾ lb ground almonds in a basin with ¼ lb sieved icing sugar and rub together lightly. Add 1 egg white, slightly whisked, and make a firm ball. Colours and flavouring can be added according to the fruits you are making.

MONDAY 7th December 1953

Stayed in bed till 3 p.m. reading *The Sisters* by Anne Meredith. Mother made me mad—she said we would have to get back in time for the choir next Monday, my broadcast day. I said it's time she had a change, after all, she's always saying she's bored with doing the same old things. I don't want to go to Manchester by myself—I'd rather get lost with somebody with me than by myself. She went with the choir to give a concert at St Luke's Hospital. Another foggy, wet day.

TUESDAY 8th December 1953

While waiting at the bus stop I felt like fainting for the very first time in my life. Dizzy, and everything went blurred. Felt very frightened. Met Edith for coffee in Sylvio's. Mother came in later. To the dentist, he says my teeth are still perfect. Shopping. Bought a larger size brassiere and knickers. Lunch in Collinson's with mother. The BBC have sent the script. Edith and Philip here for the evening, they can't wait to tune in to *Woman's Hour* on Monday. But my tummy turns turtle every time I think about it.

WEDNESDAY 9th December 1953

A reporter came from the *Yorkshire Observer* about my forthcoming broadcast. (I will receive four guineas from the BBC). He stayed talking an hour and a half. Then an *Examiner* camera man arrived and took my photograph. I believe Syd now thinks he is housing a celebrity! Evening, to look at a house on Western Road, then listened to a play.

THURSDAY 10th December 1953

Tidied up, baked buns, walked to the post office. Listened to *Woman's Hour*. In the evening Granville and I listened to a play in the front room—*Death Takes a Holiday*.

FRIDAY 11th December 1953

Shopping in town. Bought a corkscrew with a funny face on it for Granville's Christmas stocking. 2s 1d. Talking to a girl who knows Mrs Wheeler. She has the same opinion about her as I have, glad about that—didn't want to think it was merely the in-law syndrome. As I do believe that I can 'get on' with most people who are at all reasonable.

Evening, had to go to see Doctor Gilmore. Was dismayed when I had to take my clothes off while he prodded my tummy.

SATURDAY 12th December 1953

Granville to work. In town quite a number of people stopped to congratulate me on the forthcoming broadcast. They had seen about it in the papers. Bought a navy maternity smock to wear on Monday. As dark colours are supposed to be slimming.

The thought kept nagging at me, what if I get a frog in my throat on Monday,

and no sound emerges? It will have to be re-titled 'The Disappearing Christmas Casual'. To view another house with Granville this afternoon. Mick and Doreen here for the evening.

SUNDAY 13th December 1953

Cooking dinner. Afternoon, to Mrs Wheeler's with Granville for tea. Ate so much that my stomach felt to sag and ache. Played draughts, knitted, listened to the wireless and thought about tomorrow.

HOUSEWIFE'S HINT

The Christmas spirit begins to stir. Children who haven't made presents for aunts and uncles by now had better be persuaded to produce Christmas cards as an alternative because presents must soon be posted.

Gather sprays of ivy on your walks. It keeps indefinitely in water, and makes the perfect background for gay decorations.

Stretch coloured string above the fireplace, and over it hang friends' cards as they arrive; they make a lovely decoration and don't have to be moved for dusting!

MONDAY 14th December 1953

Mother seemed even more excited than me. Then we got on the wrong tram—and when we eventually reached the BBC studio in Piccadilly, Manchester, she—who can't stand broad Yorkshire—got so worked up she explained 'we got on the wrang tram' meaning wrong tram, but it came out as rhyming with tram. Didn't know whether to laugh or cry. She didn't realise what she had said—but we laughed hysterically about it later. Talk about taking her for moral support: Colin Shaw, of the Drama Department, roared with laughter and thought mother 'an absolute scream'.

First of all we had coffee in the BBC canteen, then mother waited in a large studio while I rehearsed my script next door with Mrs Mary Holmes and Colin Shaw.

MONDAY 14th December 1953

Then we put headphones on to listen to the rest of *Woman's Hour* from Manchester being rehearsed. Our scripts had to be shortened. Lunch in the BBC canteen with Mary, Colin and mother. Then dashed out to buy throat lozenges.

At 1.50 p.m. we went into another studio. Jugs of water and glasses were by each microphone. I had to wait nearly half an hour listening to the others, scrutinizing the script in front of me—remembering to 'lift' the papers so as not to make a rustling noise—before it was my turn.

The green light went on, and I began—'We can all do with a little extra at Christmas, and last year I earned almost nine pounds in one week when I became a Christmas Casual.'

Greenwich Time Signal
WOMAN'S HOUR
From the North of England
'Larpsy Diddle and Bing': his
mother's battle with the English
language, by Alan Acker
Toboggans on the Lawn: Mary
Holmes finds the snow at her
home above Malham Tarn a
mixed blessing
Housecraft for the Blind: Gwen
Pain visits a Northern cookery
class and talks to students pre-
paring Christmas dishes
Songs at the piano: Violet
Carson
The Art of Teacup Reading, by
Miranda Roberts
'I was a Christmas Casual,' by
Hazel Wheeler
(Continued in next column)

DECEMBER 1953

Kept staring at this—my name in the *Radio Times*! Would it ever happen again? It did!

Mother was sitting next door, I could see her and the producer through a long window. My face felt hot and my heart bumped, otherwise I was alright. Violet Carson sat opposite me, introducing the speakers, and to try and help me relax she kept pulling funny faces at me to make me smile, and realise that if I made a mistake, or even coughed, it wouldn't be the end of the world.

I was coming to the end of my first broadcast—'and with all that fresh air and exercise, the Christmas Casual should be in fine form for cooking a big fat turkey on Christmas day'.

MONDAY 14th December 1953

I lifted my eyes from the script to meet those of Violet Carson. She beamed, and nodded her satisfaction. Oh, that I could do it all over again; now that I knew what it felt like—I'd do it a lot better!

Home on the train. Mother, always my number one fan, kept reassuring me that I'd done it 'marvellously'. I had my reservations. But at least we were back in time for her to take the stage with the Co-op Choir. All's well that ends well.

TUESDAY 15th December 1953

Back to routine. Washed some clothes. In the afternoon a man from the estate agents called and took me in his car to see a house at Honley. Didn't go in because I didn't like the position to begin with. In the evening went to see Frances, with mother and Granville. Had to grovel our way on foot part of the way because of dense fog.

Games
FOR CHRISTMAS

Food, parties, fun and games have always belonged to our kind of Christmas. They still do.

Your party may only be the neighbours coming in for hot chocolate on Christmas Eve, or the children getting home for two days, or a precious, unexpected leave. Your party may begin in the drawing-room and end up in the shelter, but because you mean to keep Christmas you'll fix up a programme of fun and games well in advance.

Here are some games that will make your Christmas party go.

GRIM WHISTLE

This is a good sitting-still game. Each player is given a slip with the name of a tune on it by the game leader. He must whistle it through without a break in spite of efforts by other players to make him laugh or stop short by their comments. The other players guess the name of the tune if the player gets through to the end. The player who breaks down pays a forfeit, but if he gets through the others who cannot guess the tune pay forfeits. Forfeits are usually songs, recitations, and parlour tricks.

CONFESSIONS

The confessor sits in the middle and is asked by each in turn a question. His answer or 'confession' must be made in words whose first letters form his initials. For example, if the player is called George Bernard Shaw the questions and answers might be: 'How do you spend your leisure?' 'Grasping beautiful soda-syphons.' 'What is your worst fault?' 'Gorging brandy snaps.' 'What will you be like when old?' 'Garrulous, boring, snappy.'

PICK-IT-UP

You need about a pound of dried peas and a packet of lemonade straws for this. Children love this game, too. The peas must be lifted from a saucer and placed in a cup by suction through the straw. The player with most peas in his cup at the end of five minutes wins. For a number of players, run this game off in heats, as a ring of admiring spectators adds to the fun *and* the difficulty. Or pick up teams, each player holing one pea in turn.

WHOSE ZOO

Each player writes down the name of an animal and folds down the top of his paper as in 'Consequences.' The slip is then passed to the next player and the process repeated. The slips are passed four times in all, collected, shuffled, and then handed out again. The player now finds himself with a slip upon which are written the names of four animals. He must draw a creature incorporating the characteristics of all four things. It is not so easy to draw a creature that is frog, giraffe, lion, pig !

WORD SQUARE

For this you need a good-sized square divided evenly into five horizontally and also vertically. The big square should contain twenty-five smaller ones. Each player in turn calls out a letter and everyone writes it down in any square. When twenty-five letters have been filled in the winner is the player who can show most and longest complete words, either vertical or horizontal. Two-letter words do not count, but one point is counted for every letter of every word of three letters and over.

LOST IDENTITY

One player goes out of the room. The others decide upon his identity. Such persons as Julius Cæsar, Nero, Queen Elizabeth, Greta Garbo, Mussolini, are suitable examples. The first player is then invited to return and he puts questions to each other player in turn, to find out who he is. All the questions must be truthfully answered by a simple 'yes' or 'no.' Exceedingly difficult identities can be discovered after a few rounds of questions.

SEENS AND UNSEENS

A grand game for a big crowd. It needs paper and pencils. A letter is chosen and each player makes a list of things seen and unseen in the room . . . all beginning with the chosen letter. The letter is, for example, 'D'. The player writes door, drawer, diaphragm, dirt, dust, darn (on my vest), denture, etc. The unseen things prove the funniest, and in some cases players may be asked to prove their existence.

WEDNESDAY 16th December 1953

Morning, knitting. Listened to morning story on wireless. Afternoon, wrote an article about Easter in Boroughbridge, where mother was born and lived as a child. Mr Amey from the library called to see me.

THURSDAY 17th December 1953

Shopping in town. Bought two pairs each, vest and underpants to put in Granville's stocking, also a box of chocolates and one of cigars. Can't afford as much as I did last year.

We went to see *Pickwick Papers* at the Plaza after tea.

FRIDAY 18th December 1953

To the grocer's. P.M. Ironing. Evening, to Doctor Gilmore's with Granville. Talking in front room with mother, Syd and Gran., who went to the Food Office for my orange juice today.

SATURDAY 19th December 1953

Shopping, then Fields café with Granville. Heaven to be out and about and not in bed ill, or being pummelled in the tummy by Gilmore. If only one could stay alright forever.

Home for lunch then for a walk with Granville. Evening, to see *In the Wake of the Red Witch* at the Grand. Called at the Horse and Groom for a drink on the way home, then listened to a play.

SUNDAY 20th December 1953

Went for a walk by myself up the fields. Cooked the dinner. Afternoon, took a tray for a wedding present to a friend of Granville's. To Leslie's for tea, then we all went for a walk in the moonlight. Back to Leslie's for supper, home to bed.

Last but one 'Housewife' note for 1953:

> The next few days are hectic, however well planned! But see that, on one at least of the festive days, you get a rest and A MERRY CHRISTMAS.

MONDAY 21st December 1953

Mother brought our breakfasts to bed. We sat up side by side in the single bed. Granville said there was too much salt on his dripping so when she asked, shouting up 'do you want any more?' I replied 'yes, without salt'. Granville was annoyed and called me domineering. I began to cry. Mother brought more tea up.

Granville went for an interview at Leitch's chemical place near here. I had half an hour's rest stretched out instead of being cramped up in bed after he had gone. Did some washing this afternoon, then to the library in the evening with Mrs Denny.

Don't know just what I'm gonna get
But maybe this'll show
That what I WANT the MOST

Thank heaven the best presents are free (or some would never get any). Kisses fly and die but letters last forever (if kept in a diary)

TUESDAY 22ⁿᵈ December 1953

As I was ironing I fell off the buffet and hurt my back. Forgot about it when buying presents in town with mother this afternoon. Tea in Collinson's. Bought Granville a book on parenthood for Christmas. He and I went to Auntie Annie's for the evening. She gave us a clothes brush, a handkerchief for Granville, hand cream for me, and bootees for the baby-to-be.

WEDNESDAY 23ʳᵈ December 1953

Shopping again, lunch in Sylvio's with mother. Think these last few shopping days before Christmas are even better than the event itself. With the shops all brightly decorated, and everybody looking happier than usual. Bought a few more presents, then mother and I had a rum each in the Albert.

I wondered if it may harm the baby—perhaps giving it alcoholic tendencies—but mother assured me it would be alright. To the library, very busy, 175 issues. Listened to a play on the wireless in the evening with mother, Syd and Granville.

THURSDAY 24ᵗʰ December 1953, CHRISTMAS EVE

Made mince pies. Syd home at lunch time. I went to town, bought yellow stole with grey fringe for mother. A row blew up between mother and Syd on my return, she had forgotten to go to the butcher's and had no meat in.

Accustomed to dad seeing to such matters when we lived at the shop, such a mundane item had quite slipped her mind. Besides, it had been snowing, and was slippery outside.

But Syd insisted she went. Grumbling, she pulled a pair of his old socks over her boots, tucked her hair beneath her scarf, buttoned up her raincoat tightly and ventured out, gingerly, down the front steps. Granville, Syd and I watched from the front room window. Syd had refused our offer to go to see about some pork, 'she' should have done it, he maintained. It was after 5 p.m. then. The incongruity of it struck us all as the hooded figure passed out of sight behind the garages—we roared with laughing, and were quite unable to stop.

Neither could mother, when she eventually turned up, looking like Good King Wenceslas, with a brown paper parcel tucked beneath her arm.

FRIDAY 25th December 1953, CHRISTMAS DAY

To St Luke's Church, where we were married, with Granville. I sat down most of the time, even when the rest of the congregation were standing, I felt dizzy. To the Wheeler's for dinner. Wish they had invited mother and Syd, but they hadn't. So don't know what they would be eating. Called to see Gran.'s Auntie Nellie, then for the usual walk along the canal bank. When I mentioned that mother had given me a bottle of egg flip, Mrs Wheeler said that I was an 'expensive wife' and was following in my mother's footsteps. I was blazing mad—mother is a million times better than she is. We listened to the wireless all evening, me barely uttering anything else, lest it was misinterpreted, smouldering beneath my outwardly calm exterior. Longing to escape that atmosphere. Walked home.

SATURDAY 26th December 1953

Helped mother to bake. Told her what Granville's mother had said. We both told him that he ought to have said something to her. He was upset and told me later that he had been crying in the bathroom. His mother is a rotten woman, and she ought to remember who it was supplied all the deposit for enabling us to buy that first house and lots of other things. How some people can ruin Christmas, or any other time, by their thoughtless, or probably well thought-out, remarks. Granville went to the football match, then we went to Betty's for tea. Friends of theirs, Bert and Doris, were also there. At last, it felt like Christmas.

SUNDAY 27th December 1953

Baking and making jellies. Afternoon, setting the table and preparing tea. Syd's mother, his sister Doris, older sister Hilda, her husband Arthur and their three children came to tea.

Mother and Syd alright with each other again. We had a lovely tea, pork had turned up from somewhere, lashings of extra strong mustard sauce, apple sauce, everyone wore paper hats. We played games all evening. There were little presents to be won, kept hidden in the 'snow' covered gypsy caravan on the sideboard, and Sylvia, Christine and Arthur sang Christmas carols delightfully.

Mother played the piano, and Syd sang lustily. Everyone kissed beneath the mistletoe placed strategically beneath the central light, and the whole incident of the missing pork of Christmas Eve was completely forgiven and forgotten. It was Christmas, really and truly.

HOUSEWIEF'S HINT

All over and no regrets! There are still parties to give and to go to—and no party perhaps is better than the one you give on the spur of the moment!

Bread-and-butter letters must be written, and New Year Resolutions encouraged so far as the children are concerned.

And may the New Year be a very happy one.

MONDAY 28ᵗʰ December 1953
I took breakfast to bed for the others then cooked dinner. Afternoon, on the bus with Granville then walked rest of the way to Auntie Ella's for tea. In the evening we watched television and mother, Syd, Fred and Granville played cards. Syd leaned back on his chair when he was winning—never said sorry when it broke. Fred looked furious.

TUESDAY 29ᵗʰ December 1953
Granville and Syd back to work. I did some washing, mother and I concerned about a dog we have seen chained up all the time, on the fields. We went to the telephone box to ring up Inspector Lanning to report it. Came back and I baked birthday cakes for Granville—birthday January 13th, and mother January 23rd. Reading in the evening, and worrying about the chained up dog.

WEDNESDAY 30ᵗʰ December 1953
Morning, ironing. Mother and I aghast when we saw a rat running out of the coal place outside. Inspector Lanning arrived. We went up the fields with him to the dog. He is returning tonight.

THURSDAY 31ˢᵗ December 1953
On the bus to Jeanne's. Saw a rag and bone man pushing his horse in bad tempered manner. I shouted to him to stop. He yelled at me to 'get on with your washing up!' More words passed, then I walked to the Food Office with Jeanne. Afternoon, I took a few dog biscuits to the canine prisoner. Fell down the field as I was hurrying away from the geese.

Final Housewife's Hint for 1953:

We have printed this recipe for washing woollens twice in '*Housewife*.' Each time it has been enthusiastically received. Washing experts are apt to frown on it because it advises no rinsing. None the less readers continue to assure us that, washed by this method, their twin sets and finest woollies go on looking like new after many washings.

Take 8 oz. Lux or other soap-flakes, a large breakfast cup full of methylated spirit and about three dessert-spoonsfull eucalyptus oil. Mix the ingredients well (stirring with a fork is the easiest way) until there are no lumps; the mixture then looks like bread sauce tinted pale mauve. Store in a closed jar.

When required for use, give the mixture an extra stir and add a tablespoonful of it to a good sized bowl of warm water, about 4 pints. Squeeze the woollies through the suds in the usual way but do not rinse.

Roll in a thick Turkish towel and thump or squeeze out as much moisture as possible before laying out to dry (preferably flat) in the sun or gentle heat.